AMERICAN ART POTTERY

AMERICAN ART POTTERY

∎

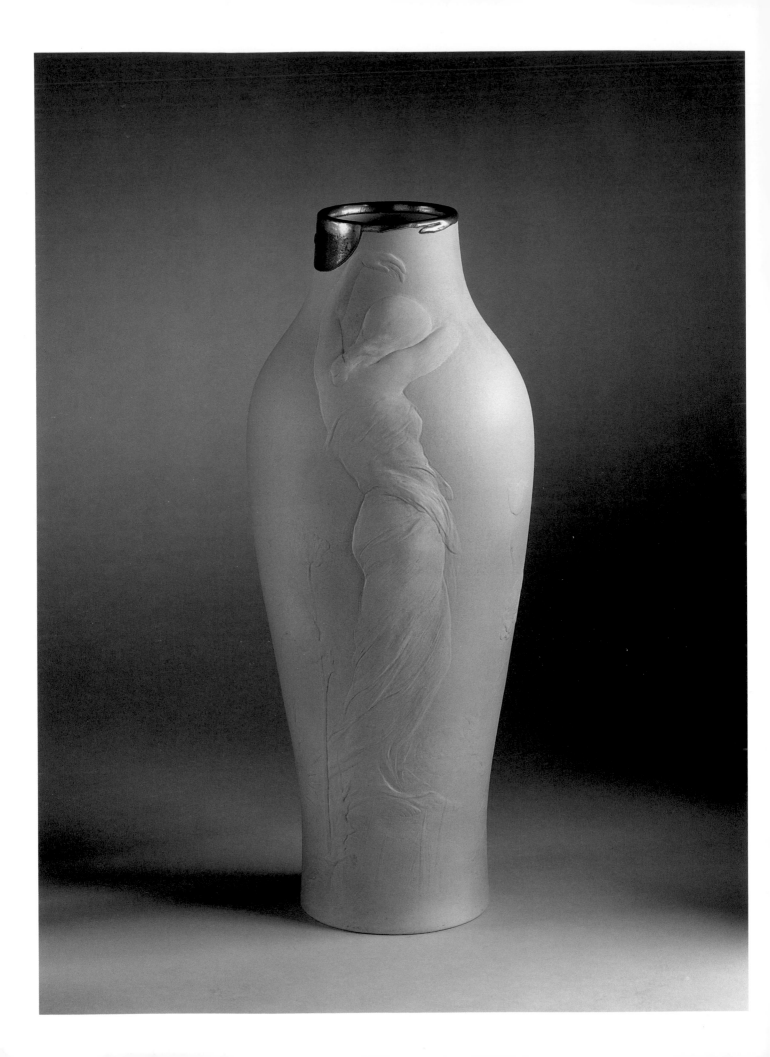

AMERICAN
· ART ·
POTTERY

SELECTIONS FROM
THE CHARLES HOSMER MORSE
MUSEUM OF AMERICAN ART

Alice Cooney Frelinghuysen

VALERIE ANN LEEDS
PROJECT DIRECTOR

■

ORLANDO MUSEUM OF ART

IN ASSOCIATION WITH THE UNIVERSITY OF WASHINGTON PRESS
SEATTLE AND LONDON

Published on the occasion of the exhibition *American Art Pottery: Selections from The Charles Hosmer Morse Museum of American Art*

April 1–September 17, 1995

Editor: Sheila Schwartz, New York

Photography: Raymond Martinot, Martinot Photo Studio, Altamonte Springs, Florida

Design: Bret Granato, Marquand Books, Inc.

Production: Marquand Books, Inc., Seattle

Printed in Hong Kong

Distributed by University of Washington Press
P.O. Box 50096, Seattle, Washington 98145

Library of Congress Cataloging-in-Publication Data
Charles Hosmer Morse Museum of American Art.
 American art pottery : selections from the Charles Hosmer Morse Museum of American Art / Alice Cooney Frelinghuysen.
 p. cm.
 "Orlando Museum of Art, April 1, 1995–September 17, 1995."
 Includes bibliographical references.
 ISBN 1-880699-04-4
 1. Art pottery, American—Exhibitions. 2. Art pottery—19th century—United States—Exhibitions. 3. Art pottery—20th century—United States—Exhibitions. 4. Tiffany, Louis Comfort, 1848–1933—Exhibitions. 5. McKean, Hugh—Art collections—Exhibitions. 6. McKean, Jeannette—Art collections—Exhibitions. 7. Art pottery—Private collections—Florida—Winter Park—Exhibitions. 8. Art Pottery—Florida—Winter Park—Exhibitions. 9. Charles Hosmer Morse Museum of American Art—Exhibitions. I. Frelinghuysen, Alice Cooney. II. Orlando Museum of Art. III. Title.
 NK4007.C47 1995
 738'.0973'07475924—dc20 94-46909

Cover: Pitcher, 1904–c. 1914; Louis Comfort Tiffany (1848–1933), designer; Tiffany Pottery, Corona, New York (1904–c. 1914) (see p. 112)

Frontispiece: Vase, 1899; Harriet Elizabeth Wilcox, decorator; Rookwood Pottery, Cincinnati (1880–1967) (see p. 50)

The exhibition *American Art Pottery: Selections from The Charles Hosmer Morse Museum of American Art* and the related programs were made possible with the generous support of:

Contributors
The Charles Hosmer Morse Foundation
The City of Orlando

Orlando Museum of Art Sponsorship Society

Benefactor:
Institute of Museum Services

Sponsors:
Council of 101; The Pino Family Foundation;
Herbert Fischer Trust

Partners:
David and Judy Albertson; The Raymond E. and Ellen F. Crane Foundation; Goldman, Sachs, & Company; The George W. Jenkins Foundation; SouthTrust Bank of Orlando; Spanierman Gallery, New York; Elsie H. Warrington Trust

Participating Fellows:
Hughes Supply, Inc.; Pam and Dale Lindon; Jacqueline Everhart McMullen; Maguire, Voorhis & Wells, P.A.; Francine and Neil Newberg; Sonny's Real Pit Bar-B-Q; Hans W. Tews

The Orlando Museum of Art is member supported and sponsored in part by United Arts of Central Florida, Inc.; the State of Florida, Department of State, Division of Cultural Affairs; and the Florida Arts Council.

CONTENTS

■

■

The *American Art Pottery: Selections from The Charles Hosmer Morse Museum of American Art* exhibition is the realization of a dream Dr. Hugh F. McKean and I have shared for many years. The Morse Museum of American Art is probably best known for its holdings of the works of Louis Comfort Tiffany, which are unparalleled. Although the Tiffany works have been featured in major exhibitions nationally, including two exhibitions at the Orlando Museum of Art, other areas of the Morse Museum of American Art's collection have received less attention. Since the Morse Museum of American Art's collection is more diversified and rich than just its Tiffany works, the Orlando Museum of Art is presenting the *American Art Pottery* exhibition to bring more attention to the depth and significance of this outstanding collection.

Organized by the Orlando Museum of Art in collaboration with the Morse Museum of American Art, this exhibition features works by leading figures from the most renowned American Art Pottery factories, such as Rookwood, Grueby, Weller, Tiffany, and others. Serving as Guest Curator for this exhibition, Alice Cooney Frelinghuysen, Curator of American Decorative Arts at the Metropolitan Museum of Art, selected exemplary works from the Morse Museum of American Art's sizable collection of American Art Pottery. Her knowledge of this collection and her insights were invaluable in making the exhibition and its accompanying scholarly catalogue a meaningful contribution to the understanding of the importance of Art Pottery to the history of American decorative arts. Valerie Leeds, Orlando Museum of Art's Curator of 19th Century American Art, served as Project Director, coordinating all aspects of the exhibition and catalogue.

For the Orlando Museum of Art to work once again with Dr. Hugh F. McKean and the staff of the Morse Museum of American Art on this exhibition was a real privilege. Dr. McKean is the quintessential connoisseur educator, and artist. To explore the Morse Museum of American Art's collection with him is always a treasured opportunity. We hope that this exhibition and the catalogue will inspire visitors as much as we were inspired by seeing this collection through the eyes of Dr. McKean.

The Morse Museum of American Art's collection is an invaluable resource. We are exceptionally fortunate to have it located in Central Florida. The City of Orlando recognizes this, and it provided significant support for the initial development of the exhibition thus ensuring its success at the Orlando Museum of Art. The support of the Orlando Museum of Art Sponsorship Society enabled the Museum to commit to a larger exhibition than originally planned and to an extended venue. The Charles Hosmer Morse Foundation's magnanimous support made the catalogue possible. This exhibition and the related programs were made possible in part by the annual support of the United Arts of Central Florida, Inc.; the State of Florida, Department of State, Division of Cultural Affairs; and the Florida Arts Council.

Marena Grant Morrisey
Executive Director
Orlando Museum of Art

PREFACE

■

After all the triumphs of modern art, we dress to the nines, sip a little wine, and stroll through smart galleries filled with pottery made for turn-of-the-century parlors. Art Pottery is fashionable again and the inquisitive mind naturally asks, "Why?"

It is really no mystery. Art Pottery was part of the reaction against machine-made art. Many American potteries making it were staffed and managed by women, which suggests that the industry may have been fueled by some of the ideas underlying the impending women's liberation movement. The American potteries' acceptance as world leaders in the production of art ware gave our young country welcome self-assurance.

The reasons for today's interest are real and understandable. Art Pottery played a significant role in our own discovery of America. But there is something else. We are looking at Art Pottery as art, not as visual history. We are fascinated with its reliance on skill and craftsmanship. We are learning the styles of individual artists and artisans. We are not insensitive to the fact that Art Pottery can give pleasure as well as refresh the spirit, and that it does so with a touch of heart-warming humility.

It is possible that as we sip our wine and reflect on these gentle vessels we are wishing we had something like Art Pottery for the parlor of our own society.

> Hugh F. McKean
> Director
> The Charles Hosmer Morse Museum
> of American Art

ACKNOWLEDGMENTS

■

My introduction to the unknown riches of the Art Pottery collection in The Charles Hosmer Morse Museum of American Art came in April 1987, when Hugh F. McKean invited me to Winter Park to review and comment on the museum's art pottery holdings. Many of the pieces I saw during that early visit eight years ago have been indelibly marked in my mind. It was, therefore, with great delight that I received the invitation from the Orlando Museum of Art to guest curate an exhibition of American Art Pottery from the Morse Museum.

One of the most difficult tasks of the project was whittling down the number of objects for the exhibition from over eight hundred to about one hundred seventy-five. Each rejected object has a story to tell, but must remain for another project. With the ensuing selection, I have attempted to choose objects that would amplify the story of the making of Art Pottery in America, while at the same time attempting to accurately reflect the nature of this highly individualistic collection.

A number of people have facilitated my work and made this project a particular pleasure. First, at my own institution, I am grateful to John K. Howat, Chairman of the Departments of American Art, for encouraging me to undertake the project, and to Philippe de Montebello, Director, for his approval. Many members of the curatorial and administrative staff of the Department of American Decorative Arts provided encouragement and assistance along the way. I wish to extend special thanks to two volunteer interns at the Metropolitan, Yasmin Ellis Rosner and Cindi Strauss, without whom this catalogue would not have been possible.

I am grateful to Marena Grant Morrisey, Executive Director of the Orlando Museum of Art, for initiating the exhibition and catalogue with the Morse Museum and for having the foresight to recognize the quality of the collections there and for enabling them to be brought to Orlando for a wider audience. Many other members of the staff of the Orlando Museum have provided assistance in countless ways. I especially want to give heartfelt thanks to Valerie Leeds, Curator of 19th Century American Art, for shepherding the project through from beginning to end with such professionalism and good humor. Hansen Mulford, Curator of Exhibitions, is to be credited for the exhibition's sensitive design. Also from the Orlando Museum of Art's Exhibitions Department, the organizational and administrative efforts of Betsy Gwinn and Andrea Farnick were vital to the exhibition and catalogue. I thank Sheila Schwartz for her careful editing despite a short production deadline. Marquand Books was responsible for the catalogue design that eloquently complements the subject. Special recognition must be extended to Raymond Martinot, whose photographs faithfully render the beauty of the objects. His patience and skill made the lengthy and complex photographic process flow smoothly.

Many individuals at The Charles Hosmer Morse Museum of American Art and The Charles Hosmer Morse Foundation gave me much needed assistance and counsel. Every-

one there did all they could to make my visits to Winter Park as easy and productive as possible. However, a few must be singled out for special credit. I am indebted to Laurence Ruggiero, Associate Director, for facilitating the administrative aspects of the project at the Morse Museum. Appreciation is also due to other Morse Museum staff members—Jackie Howell, Madeleine Lamprecht, and David McDaniels. David Donaldson, Conservator, has been a fountain of information on the collection, and he has generously and graciously shared his knowledge and insights with me. David's familiarity with the collection and knowledge of many technical aspects of the pottery have been invaluable.

American Art Pottery: Selections from The Charles Hosmer Morse Museum of American Art would not have been possible without the enthusiasm and support of Hugh F. McKean. Not only did he assemble the collection, but he also has spearheaded the effort to bring it to the attention of both connoisseurs and lovers of pottery as well as the general public. In addition, his reminiscences on the collection have helped to give it color. Most of all, his warm and generous hospitality during my visits to Winter Park gave me welcome respite and enormous pleasure.

<div align="right">

Alice Cooney Frelinghuysen
Curator, Department of American
Decorative Arts
The Metropolitan Museum of Art

</div>

INTRODUCTION

■

Alice Cooney Frelinghuysen

Over the past four decades, Jeannette and Hugh Ferguson McKean have assembled a sizable collection of American Art Pottery, numbering over eight hundred individual pieces. This endeavor was a natural offshoot of their primary focus, the work of Louis Comfort Tiffany in all its facets, for which The Charles Hosmer Morse Museum of American Art is now justly famous. It is this little-known, yet rich, aspect of the Morse collection that the Orlando Museum of Art has chosen to highlight in a special exhibition and catalogue, displaying and illustrating just a fraction of the total collection.

It is not surprising that the McKeans embarked on collecting pottery early on. Hugh F. McKean's ancestry includes members of the Thompson family, important figures in the ceramics factory that bore their name in East Liverpool, Ohio, once the largest ceramics manufacturing center in this country. The collection has impressive scope, including many of the major figures in the Art Pottery movement, such as Rookwood, Grueby, Weller, and Tiffany, and, to a lesser extent, representative examples from numerous other factories that help present a more complete picture.

The collection ranges from pieces that are almost unique works of art, among them a vase in pottery and metal by Maria Longworth Nichols Storer, to pieces that are virtually mass produced, such as later examples of Rookwood and Van Briggle. It also spans a broad chronological range, from the earliest efforts in Art Pottery in the late 1870s, to the Cincinnati work of the early 1880s, to very late Rookwood of the 1950s.

The collection reveals a profound commitment to the work of Louis Comfort Tiffany in its seventy examples of pottery by Tiffany's studio, the largest collection of its kind in the world. Tiffany favrile pottery and favrile bronze pottery, as he called it, is a relatively unknown aspect of his oeuvre. In fact, this project places special emphasis on the Tiffany collection at the Morse Museum in the hope that it will reveal new insights into that facet of Tiffany's work and encourage the study of the full range and depth of the artist's abilities and achievements.

Hugh McKean is exceedingly modest in his expressions about the collection, but it is clear that he was guided by a strong commitment to the ideals valued by Tiffany, notably Tiffany's focus on the natural world and his interest in color. Hugh and Jeannette McKean's personal interest in nature intensified their empathy with Tiffany's work. In addition, they both had a healthy regard for and interest in the role of women in the making of American Art Pottery.

The ceramics collection was formed over many years. No one dealer dominated the choices of objects. Each one was selected personally by Jeannette or Hugh McKean, assisted by David Donaldson, conservator at the Morse Museum for the past seventeen years. Objects were purchased at auction, from some of the noted New York dealers who specialized in the field, and from modest local sales and dealers. Never did any fanfare surround the purchase of an object. The McKeans' collection was supplemented by a generous gift from Mr. and Mrs. Herbert O. Robinson of Winter Park, particularly in the area of Rookwood pottery. The Robinsons' interest in the medium may have initially been sparked by Hugh McKean's infectious enthusiasm.

The collection the McKeans formed reveals a remarkable aesthetic range and has great depth in specific areas. In addition to the work of Tiffany, the Rookwood firm is represented in virtually all facets of its production. Nevertheless, there are the inevitable gaps, most notably the work of the Chelsea Keramic Art Works, some of the more fantastic shapes of George Ohr, and early examples of the Van Briggle Pottery. Tiles were also not acquired extensively, although the collection does include a small group of the Moravian tiles of Henry Chapman Mercer that had originally been at Laurelton Hall, Tiffany's Long Island country home.

The specific works shown and illustrated here represent an impressive variety of artistic achievement in the ceramic medium in America during the late nineteenth and early twentieth centuries. The collection as a whole, however, though wide-ranging and aesthetically diverse, remains personal, the product of two people's passionate and private pursuit.

AMERICAN ART POTTERY:

SELECTIONS FROM THE
CHARLES HOSMER MORSE MUSEUM OF AMERICAN ART

■

Alice Cooney Frelinghuysen

American Art Pottery is the generic name used to designate ceramics made with a consciously artistic intent during the period roughly from the time of the Philadelphia Centennial Exhibition of 1876 until the beginning of World War I. The label, however, is perhaps more problematic than most, encompassing as it does ceramics widely varying in method of fabrication and decoration. Consequently, examples of Art Pottery look very different from one another. For instance, Art Pottery includes both ceramics made in a single potter setting, such as the work of George E. Ohr (see p. 147) or Adelaide Alsop Robineau, and those fabricated in a highly organized factory, such as the Rookwood Pottery. In many cases, women decorated the pottery and even founded successful potteries, as did Maria Longworth Nichols (Rookwood) and Mary Chase Perry (Pewabic), while others, like the Grueby Pottery, were male-dominated enterprises. Perhaps the most significant pitfall for such a singular designation is the fact that there is an extraordinary variety in the types of objects produced that are today called Art Pottery. Some feature painted decoration, carefully executed in a naturalistic manner; others rely on form and colored glazes for aesthetic effect. Some are hand-thrown or hand-built; others are cast or molded into shapes. A remarkable range of different glazes was also produced during the period in question, resulting in vessels with highly varied and distinct appearances. Yet it is the very diversity of these ceramic works that makes them so appealing today.

American Art Pottery was considered special by its makers. Great care was taken with the vessel's design, fabrication, and decoration. Often the piece, like a work of art, was signed not only by the pottery, but also by its decorator, and sometimes by the modeler or potter as well. Such wares were exhibited at special showings at decorative arts societies in cities across the country. They were sold in some of the finest china stores, from Davis Collamore and Tiffany & Co. in New York to Caldwell's in Philadelphia. Examples of American Art Pottery were virtually the first American ceramics to receive international acclaim when exhibited at the great international exhibitions, where they were awarded high commendation from the juries and garnered significant attention from the press.

The diversity of American Art Pottery is demonstrated admirably in the holdings of the Morse Museum. Naturally, the core of the ceramics collection is the work of Louis Comfort Tiffany, whose work in all other media is the great strength of the museum as a whole. The other major holdings are the products of the Rookwood Pottery, the largest and longest lasting of any of the art potteries that commenced operation in America during the final quarter of the nineteenth century. Representative examples illustrate vir-

tually the full range of that factory's production. What characterizes the majority of the work in the collection, and what becomes the dominant leitmotif of the exhibition, are many of the same influences that motivated Louis Comfort Tiffany during his remarkable career in the arts, notably an intense interest in nature and color.

The second half of the nineteenth century witnessed a cultural reawakening to nature. Tremendous attention was focused on the natural landscape, and gardens and plants achieved heightened importance. Publications on gardening and landscaping, and especially flowers, flourished during the late nineteenth century as never before.[1] The opening of arboreta, beginning with the Arnold Arboretum, established near Boston in 1872, gave artists and the general public the opportunity to enjoy and study an amazing variety of plants, shrubs, and trees. This new direction would dramatically influence the forms and decoration produced by American art potteries. Indeed, several art potteries, A.H. Hews & Company, Chelsea Keramic Art Works, Galloway and Graff, and Teco among them, evolved from firms that handled a steady production in red earthenware flowerpots and other utilitarian garden pottery. Much has been written about the new attention devoted to the artistic creation of the home according to the ideals of the Arts and Crafts Movement, whereby the moral character of the inhabitants would be strengthened by adhering to solid Arts and Crafts principles of decoration. So, too, gardens, whether in the form of a large public park or a small private border, were considered beneficial to everyone. One author, writing in 1871, stated that "A beautiful garden, tastefully laid out, and well kept, is a certain evidence of taste, refinement and culture."[2]

Gardens and gardening, like china painting, were avidly pursued by cultured women of the day. Many of the newly published garden guides catered directly to the amateur lady gardener. Gardening also became a preoccupation with serious professional artists, and their carefully constructed views of nature often provided them with subject matter for their art. Louis Comfort Tiffany had an insatiable enthusiasm for gardens, as evidenced by the many elaborate ones he created for Laurelton Hall, his country home in Long Island. He also maintained an extensive library of books and encyclopedias on nature, plants, trees and shrubs, flowers, horticulture, and gardening.[3] Many of the flowers and plants within those volumes provided ample inspiration for Tiffany's pottery vases.

Running parallel to the escalating interest in flowers and gardens during the third quarter of the nineteenth century was an unprecedented interest in ceramics. The collecting of ceramics from foreign nations reached a feverish pitch, spawning such satirical references as "the ceramics craze," "the china mania," or "the rage for old china." Ceramics of varied origins were incorporated as important elements of interior household decoration and were used to embellish tabletops, mantel shelves, even walls. They were collected and displayed for their decorative value, and could help make a "room brilliant, cheery, and full of bright thoughts."[4] Those who could not afford the real thing could purchase wallpaper depicting various plates and vases displayed on a wall ledge. The same period signaled an unprecedented proliferation of the printed word and, more important, the printed picture. Newspapers, magazines, and journals published illustrated articles on all the arts, featuring pottery and porcelain in greater numbers than any of the other decorative arts. Such publications became widely available both here and abroad

to artists, craftsmen, designers, and the general public. The great international exhibitions of the nineteenth century, in this country notably the 1876 Centennial Exhibition in Philadelphia, prominently featured pottery and porcelain among their myriad displays. Museums and decorative arts societies across the nation began to exhibit and acquire examples of pottery and porcelain, both contemporary and antique, of domestic manufacture and foreign.

These outlets for ceramics and the widespread exposure given to the medium became a tremendous resource for potential ceramicists. Surviving documentation from the Rookwood Pottery reveals the large extent to which designers relied on such sources. Besides having an extensive library available to its workers, the pottery financed travel for its artists so that they could study works of art that might serve as inspiration. Rookwood drew on local sources as well. Indeed, the variety seems endless. The manuscript recording of Rookwood's products, the "Rookwood Shape Record Book," indicates that the pottery copied such diverse models as antique examples from ancient Greece, Japan, and China to contemporary vessels made by Theodore Deck, Doulton, Gallé, Haviland, Royal Worcester, Minton, and Wedgwood.[5] Even the products of contemporaneous American potteries were copied, as were, for example, a vase with a sang-de-boeuf glaze made by Hugh C. Robertson's Chelsea Keramic Art Works that was on exhibition at the Museum of Fine Arts, Boston, or vases made by Frederick Dallas or Matt Morgan.[6] Non-ceramic items, such as Indian baskets, "a silver coffee pot from Bigelow, Kinnard and Company," and an "old silver plate candlestick," also inspired works produced by the pottery.[7]

It was undoubtedly this intense interest in ceramics at a critical moment at the time of the Aesthetic Movement in America, and coincident with the nation's celebration of its hundredth birthday, that initiated a movement by women to decorate china. The movement was nationwide and within a few decades the number of women engaged in china painting swelled into the hundreds of thousands.[8] In Cincinnati, which became a center for this activity, it was more than a gentle female pastime. Numerous women took up china painting both as a serious vocation and as an artistic outlet. The most notable of all was M. Louise McLaughlin, the first person in this country to experiment with a type of underglaze painted decoration that utilized colored slip (or liquid clay), a technique called *barbotine*, which was based on the work being made at the Haviland factory in Limoges, France. Haviland exhibited examples of their new *barbotine* wares at the Centennial Exhibition, where McLaughlin was also an exhibitor. The French displays had a tremendous impact on her and others, compelling them to seek ways to emulate the technique, shapes, and painted subjects. Jennie Young, writing in 1878, observed: "The peculiar talent of the artists consists in producing an effect of boldness and carelessness with a great deal of work and a close imitation of nature. . . . But the process is different, and after the firing the detail of the work melts away, leaving behind that fascinating harmony of colors which has never before been produced on any pottery."[9] Young continued: "We are struck by the originality of their [Haviland's] shapes, the freedom of their designs, and the remarkable depth and beauty of their coloring."[10] The French *barbotine* wares made in Limoges or Bourg-la-Reine became highly popular with culturally sophisticated Americans and were sold in the best china stores, Tiffany & Co. and Davis Collamore among them.

McLaughlin's contribution to the emerging interest in making and decorating artistic ceramics, both on a professional and amateur level, cannot be underestimated. In addition to her extensive output, McLaughlin wrote numerous articles on the subject in periodicals of the day and published four books on it, the most influential, *Pottery Decoration Under the Glaze*, appearing in 1880, the first English-language published account of the *barbotine* technique.

In 1877 McLaughlin's successful experiments with Limoges-style underglaze slip-painted earthenware, dubbed "Cincinnati Faience," took place at the Coultry Pottery in Cincinnati. P.L. Coultry & Co. maintained a steady business in "Rockingham and Yellow Ware," marketing the type of utilitarian factory-molded pitchers, bowls, and spittoons that had been in production at the factory since its founding in 1859. The firm's first foray into artistic wares, following the example of the New England potteries, notably, A.H. Hews & Company and Chelsea Keramic Art Works, were vases modeled on Egyptian, Greek, and Roman forms. With McLaughlin's involvement, and with the employment in 1879 of the young artist Thomas Jerome Wheatley to decorate the wares and to teach pottery decorating, the Coultry firm achieved a respected reputation for their slip-decorated faience. Together, McLaughlin and Wheatley can be credited with founding the Cincinnati Art Pottery movement that would have an enduring influence well after the turn of the century.[11]

Wheatley's tenure at the Coultry Pottery lasted less than a year before he established his own firm, T.J. Wheatley & Company, in April 1880, where he continued to produce *barbotine* wares. The early Cincinnati decorators used shapes borrowed directly from their French counterparts. Flat-sided rectangular vases or pilgrim vases predominated, providing an ample ceramic canvas on which to execute their painterly designs. The selection of objects by the Coultry and Wheatley potteries from the Morse Museum features primarily floral motifs (fig. 1). A spray or bouquet of flowers, set to one side and rooted at the base of the vase, is displayed on a mottled background recalling the asymmetry of Japanese composition. The floral motif is executed in a heavy impasto so that it stands out texturally from the background. Figural and landscape compositions were occasional subjects on *barbotine*-style works from the Coultry Pottery. One particularly large vase features a Venetian landscape painted with heavy impressionistic brushwork (p. 37).

Sculptural decoration achieved by applying hand-modeled flowers or sea creatures to the vessel, in a decorative style then being made in Limoges, also influenced the work of the Cincinnati potters. Bearing strong Japanese influence are the vases encrusted with applied decoration in the form of seaweed, shells, and grotesque sea creatures. Wheatley is known to have executed examples in this Japanese grotesque genre. One such vase (fig. 2) features, in addition to the dripping undersea vegetation (formed by forcing the wet clay through cheese cloth), clam and scallop shells, a crayfish, and a newt on a mottled background.

Natural forms interpreted in a Japanese mode were a preoccupation of another early and influential Cincinnati woman, Maria Longworth Nichols. Like McLaughlin, Nichols began her serious ceramic work at the Dallas Pottery in Cincinnati, but soon struck out on her own, having felt slighted by McLaughlin.[12] As a result, she founded her

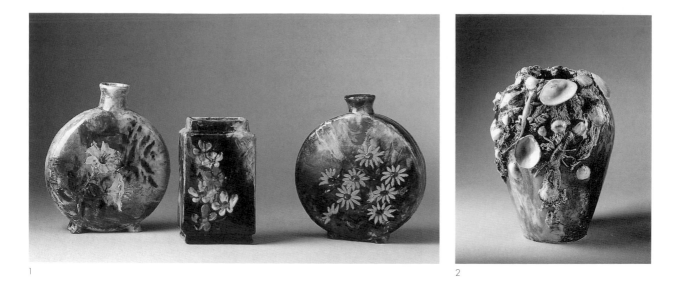

own pottery in the summer of 1880 and named it Rookwood after her family's home. During the Rookwood Pottery's early years, Nichols engaged a number of professional decorators, Albert R. Valentien, Nicholas Joseph Hirshfeld, and Matthew A. Daly among them. The designs executed by Nichols and her team incorporated the underglaze slip technique of McLaughlin and designs inspired by Japanese prints.[13] Floral motifs painted in heavy impasto over dark, mottled backgrounds were characteristic products of Rookwood's earliest decorators (pp. 39, 40). In some cases, individual decorators chose identical subjects, and even selected the same standard shapes on which to execute their designs; each would achieve slightly varying results.[14]

The interest in Japanese art manifested by designers at the Rookwood Pottery in fact had been widespread among designers and artists throughout the Western world ever since Admiral Perry opened up trade with Japan in 1853 and Japanese goods began flowing to Europe and America. "Japonisme," however, reached a fever pitch during the 1870s and 1880s. The French artist Emile Gallé was particularly inspired by Japanese art, and examples of Gallé's faience were available in America, even in Cincinnati. Gallé's unusually shaped vases were especially admired by the Rookwood potters, and no fewer than four shapes were modeled directly on Gallé's examples.[15] One such vase, for which a Gallé prototype exists, is in the form of a crushed vase with two small rectangular handles (fig. 3). To carry through the Japanese theme, the decoration that Nichols painted on the vase was, no doubt, directly inspired by motifs found in Japanese prints, a source utilized by Rookwood's other decorators as well. The underglaze slip-painted technique perfected by Rookwood's decorators was also adapted to more varied subject matter. For example, the noted decorator Albert R. Valentien painted a mysterious wooded landscape in grisaille tones on one large ovoid vase (p. 42).

Although the influence of Japan dominated the decoration of Cincinnati pottery in the early 1880s, Near Eastern cultures were also mined for their decorative potential. Some examples, such as a pair of vases made by the multitalented Matt Morgan (fig. 4), evoke Moorish ornament and art in their patterned surfaces, lustrous dark blue glazes, and lavish use of gilded decoration. Rather than adapt Japanese forms or reproduce examples

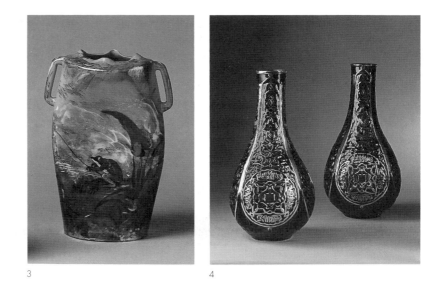

3 4

from the ancient world, Morgan had become fascinated with so-called Hispano-Moresque pottery that he saw on his travels to Spain.[16] Pottery of this type was also being collected at the time by such prominent figures in the American artistic community as Louis Comfort Tiffany and Samuel Colman. When Morgan introduced his novel vessels based on Moorish water jars and vases in early 1884, they elicited considerable enthusiasm.[17] The Rookwood Pottery and the Cincinnati Art Pottery also created an aura of exoticism with a line of vessels embellished with polychrome floral decoration and gilding (pp. 44, 45).

The interest in the *barbotine* mode of painted decoration waned after a few years. At Rookwood it began to be replaced by painted wares that featured a smoother, more refined background, revealing subtle harmonizing color gradations from the top to the bottom of a vase. This singular type of decoration was invented in 1884 at Rookwood by Laura Fry, one of the firm's noted women decorators, when she developed the technique of creating the background color with thinner slips applied through a mouth-blown atomizer.[18] The earliest and most common ground colors were warm earth tones that shaded from yellow or orange to brown or greenish-brown, known as Rookwood Standard ware. With their smooth, shiny surfaces, delicately painted floral decoration, and simple vase forms often based on Chinese prototypes, the Rookwood wares made from about the mid-1880s were renowned for their lustrous elegance (pp. 51–55).

The pervading interest in naturalism, and flowers in particular, made floral designs the most common subject matter for Rookwood Pottery throughout the 1880s and 1890s. In the manner of botanical illustrations, the detailed floral portraits were removed from any contextual setting yet revealed the decorators' concern for botanical accuracy. They are reverential depictions of specimens silhouetted against delicately shaded backgrounds. Individual blossoms were studied from nature. The decorators copied living flowers picked from Rookwood's own gardens or the surrounding countryside. This was amplified by the illustrations found in the numerous periodicals and books housed in the pottery's extensive design library. In an attempt to provide the decorators with additional floral subject matter, William Watts Taylor, who was hired as the pottery's business manager in 1883, even purchased natural materials from far afield. In July 1892, for example,

fig. 3
Vase, 1882
Maria Longworth Nichols
(1849–1932), decorator
Rookwood Pottery, Cincinnati
(1880–1967)
(p. 39)

fig. 4
Pair of vases, c. 1884
Matt Morgan Art Pottery,
Cincinnati (1882–84)
(p. 43)

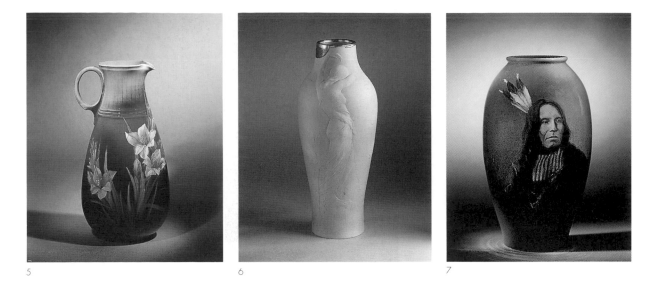

5 6 7

Taylor ordered a shipment of water lilies from a Boston supplier, and then had them photographed to be added to the pottery's design repertoire.[19] In another instance, decorator Albert R. Valentien demonstrated his particular affinity for floral subjects by executing numerous studies of wildflowers on a trip to Germany financed by the pottery in 1899 and 1900, and again when he traveled to California in 1903.[20] Daylilies, dogwood blossoms, and the pitcher plant are but a few of the floral motifs depicted on the Rookwood vessels in the Morse Museum (fig. 5).

Figural decoration was a less common, yet important, aspect of the decorative vocabulary of the Rookwood Pottery. Matthew Daly, who painted numerous floral designs, also executed a detailed naturalistic rendering of an old Japanese man wearing clogs and holding a bamboo stalk (p. 58). Harriet E. Wilcox, one of the pottery's decorators who favored floral subjects, depicted a female figure in diaphanous garb awakening in a field of poppies (fig. 6). In this exceptional vase, entitled "The Garden of Eden," the figure is created in relief in a monochrome white clay. The sculptural quality is further accentuated by the artist's decision to leave the piece uncolored and to give it a smear glaze resulting in a dull or mat marblelike finish.[21]

Perhaps as an extension of the prevailing reverence for nature, during the 1890s several Rookwood decorators undertook portraits of Native Americans, who were romantically perceived to live close to nature (fig. 7; pp. 59–61). For their Native American portraits, the Rookwood artists painted primarily from photographs rather than from life. Some of these portraits in pottery were taken from documentary photographs commissioned by the Smithsonian Institution, copies of which the pottery may have acquired for use by their decorators. Other artists may have copied photographs commissioned by the pottery itself. In 1895 a group from the Cree tribe from Havre, Montana, and in the following year a group of Sicangu Sioux, camped on the grounds of the Cincinnati Zoological Gardens, having been abandoned by one of the traveling Buffalo Bill Wild West shows, and it is likely that their presence was photographically recorded at the time.[22] Grace Young, Frederick Sturgis Laurence, and Matthew A. Daly were three Rookwood decorators who were particularly noted for their depictions of Native Americans.

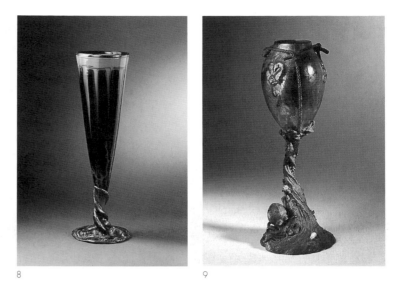

8 9

As has been demonstrated, Maria Longworth Nichols was deeply involved with Japanese art. During the early years of Rookwood, when she was enlisting talented decorators, she avidly sought a Japanese artist. She finally succeeded in 1887, in hiring Kataro Shirayamadani, who is acknowledged to have been one of the finest decorators of the firm; he enjoyed a lengthy career there, working until his death in 1948.[23] In addition to delicate floral and figural painted pieces, he perfected a new, short-lived output of vases ornamented with metal mounts or electroplated designs. Historically, fine ceramics were given enhanced importance by the addition of ornamental metal mounts. Rare Chinese and French porcelains had been decorated with gilt-metal ornament at least since the eighteenth century. Due to the high cost of production, electroplated ceramic wares— although of exceptional conception and execution—were made at Rookwood only for a brief period, from about 1898 to 1903. Typically, they featured such Japanesque decoration as exotic creatures and marine plant life, often complementing the painted images. A small vase with a dark Standard glaze features a bat clinging to the lip (p. 62). One of the more dramatic examples is a tall, trumpet-shaped vase with an abstract painted design, the vase held aloft by a grotesque octopus (fig. 8).

Such metal-and-ceramic pieces may have been inspired by Maria Longworth Nichols' experiments in the new mixed media. After Nichols married Bellamy Storer, Jr., in 1886, she began to devote less time to Rookwood, and in 1890 she signed the pottery over to William Watts Taylor, who had worked in a supervisory capacity almost from the pottery's founding. By about 1896, Maria Longworth Nichols Storer turned her attention to metalwork designs, often in combination with ceramic vessels. The result is a small number of extraordinary works which reveal her highly individualistic artistic sense. Works such as the vase in the Morse collection (fig. 9) are exceedingly evocative of Japanese art. Enclosed in a cast and patinated white metal mount simulating twisted and knotted rope, the vase features a molded design of three repeated seahorses. The base reinforces the aquatic theme in its sinister octopus with eyes of semiprecious stones amid sea grasses and waves. The vase features a lustrous glaze of copper color with an iridescent finish. The metallic appearance of the surface serves as a link to the metalwork mount.

fig. 8
Vase, 1900
Kataro Shirayamadani
(1865–1948),
designer and decorator
Rookwood Pottery, Cincinnati
(1880–1967)
(p. 63)

fig. 9
Vase, 1897
Maria Longworth Nichols Storer
(1849–1932), designer
Rookwood Pottery, Cincinnati
(1880–1967)
(p. 64)

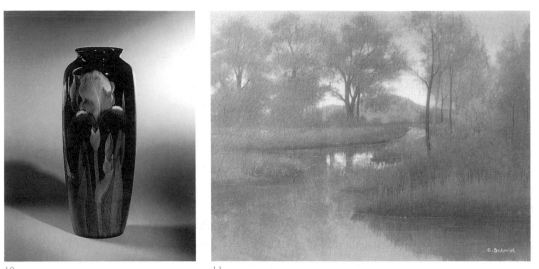

10

11

Two baroque pearls complete the picture. On the one hand, the lustre of the two pearls echoes the iridescence on the glaze; on the other, the pearls also evoke the sea by reference to their origin in an oyster shell. The overall composition is deliberately asymmetrical from every vantage point.

In the 1890s, inspired in large part by an international interest in developing different glaze treatments, Rookwood began to introduce various new glazes which, as a clever marketing ploy, were given evocative names that conjured up natural images: Iris, Sea Green, and Aerial Blue, for example. In stark contrast to the deep earth tones of the Rookwood Standard glaze, these new styles were cool, delicately shaded glazes derived from examples made in Europe, notably at the Royal Copenhagen Works in Denmark. Again, floral motifs dominated such decoration. The Iris glaze—which encompassed a wide palette wherein the color faded imperceptibly from dark to very light—was particularly suited as a background for the depiction of flowers (pp. 68–71). Albert R. Valentien said that in the Iris glaze "I felt that I could express all the quality of tenderness that the real flower contained, perhaps even more fully than on paper or canvas, as the soft tones of the clays were well adapted to and lent themselves readily to this end."[24] He might have been speaking of the iris blossom itself. Its detailed representation on a vase with a deep Black Iris glaze by Charles Schmidt achieves striking luminosity by the application of an ultra-shiny transparent glaze over the entire piece (fig. 10). The blossom is rendered with exquisite detail and reveals a thorough botanical accuracy. It floats on the background as if detached from space in much the same way as in Japanese painting. Examples of the Black Iris glaze were acclaimed when they were sent for exhibition at the 1900 Exposition Universelle in Paris.

Rookwood was as renowned on an international level as it was in the United States. Its products were unstintingly admired by avant-garde dealer Siegfried Bing, an influential figure in the sophisticated Parisian art world by the end of the nineteenth century. Bing praised the pottery as having "gone boldly ahead in new artistic directions. Its products, using the technique of colored enamels, are closely akin to similar experiments which have been carried out in France over the last few years. . . . The Rookwood Company

unhesitatingly hired Japanese artists as instructors, thus avoiding many mistakes."[25] In that 1895 essay, Bing accorded Rookwood "equal rank with the European establishments of similar character."[26]

During the last decade of the nineteenth century and the first of the twentieth, nature was given a sense of place by Rookwood decorators on vases and plaques with atmospheric renderings of landscapes (fig. 11). Such scenic works take the form of carefully constructed landscapes, devoid of people and suggestive of a particular place, with characteristic fuzzy contours for the trees and leaves, a soft, muted palette, and a glowing quality of light as it suffuses the various landscape elements (pp. 83–87). The landscapes made use of the Vellum glaze—one with a transparent mat finish—developed by the company in 1904. While the mirror-finish high glaze of the Standard and Iris glaze florals enhanced the hard contours and accurate depictions of floral specimens, the dull finish of the Vellum glaze accentuates the dreamy, impressionistic quality of the landscapes, while at the same time catering to the then-current vogue for mat glazes. The hazy vista of sea life viewed under water was also considered suitable for such a glaze (p. 88).

The landscape subject matter was treated in a two-dimensional manner, as if a canvas had been wrapped around a three-dimensional vessel. The canvaslike aspect of such scenic renderings made them particularly suited to plaques. Although the Rookwood Pottery had a thriving business in architectural tiles, such two-dimensional forms were, except for advertising plaques (p. 89), used almost exclusively for landscapes with the Vellum glaze. Unlike tiles, which would have been incorporated into an architectural setting, many of the plaques were originally framed and hung on the wall of an interior as small-scale paintings.

In much the same way that the mat-finish Vellum glaze was suited to Rookwood's fuzzy contoured scenic views, Rookwood's colored mat glazes also seemed to dictate a new style in the rendering of flowers. During the late 1890s and early 1900s, vessels in Rookwood's mat glaze line provided evidence of a distinct shift away from the meticulous depictions of singular blossoms to a more decorative treatment, whereby flowers, or in some cases peacock feathers, were more stylized, even geometricized, for decorative effect (pp. 74–77). The overall designs became bolder than the more naturalistic style of earlier work. Sometimes, as in the case of a decorated tea set (fig. 12), the floral or leaf motif was so abstracted that the source is virtually unrecognizable. On the tea forms, the leafy vine decoration has been reduced to simple geometric triangles on short, straight stems joined to the vine, which is an incised straight ring encircling the vessels. The linear quality of such pieces is further emphasized by the carved, or incised, detail. At the same time, the colors often became bolder and less naturalistic, employing more strident hues and color combinations (pp. 78–81). The new color range was made possible, in part, by the firm's introduction in 1910 of the Soft Porcelain body.[27]

Rookwood's mat glaze continued to be used throughout the duration of the pottery, until its closing in 1967. In particular, it appeared on mass-produced pieces such as vases and bowls as well as on more sculptural forms—like ashtrays, candlesticks, bookends, and figurines (pp. 90–93). These later works, generally not signed by individual artists, were multiples, produced in molds and featuring monochromatic glazes in various colors.

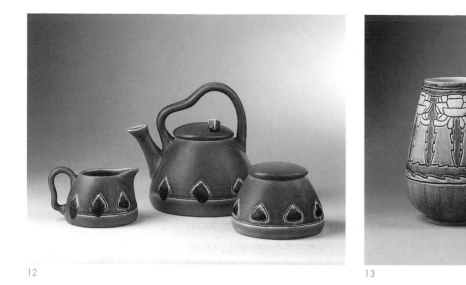

12

13

They had none of the time-consuming hand-painted decoration typical of earlier Rookwood pieces.

Rookwood's post-1920 wares, although never considered avant-garde, followed changing trends in artistic style and design. In the late 1920s, William E. Hentschel, for one, produced a number of vases which feature variations on consistent themes and styles. They are sometimes characterized by fine concentric ridges at the lower section of the vase. The painted decoration typically consists of different versions of stylized leaves and seeds, generally rendered in a subdued palette restricted to only a few, closely aligned hues (pp. 94–96). During the 1920s the factory hired three foreign-born decorators, Louise Abel, Catherine Pissoreff Covalenco, and Jens Jacob Herring Krog Jensen. Jensen was responsible for those wares which closely resemble contemporaneous examples made at the Royal Copenhagen factory in Denmark (p. 97).

The distinctive architectural style of Art Deco, popular in the 1920s and early 1930s, is recalled in a small, almost spherical Rookwood vase with a geometric design in relief (p. 98). The whole is covered in a shiny, rich purple glaze. During its last decades, the pottery attempted to remain modern in some of its artistic wares although these were overshadowed by the large quantity of production pieces being manufactured at the time. Even when the pottery was struggling for its very existence, John Delaney Wareham, who took over the declining firm in 1934, produced two vases, severely Oriental in form, with an opaque glaze in a brilliant turquoise applied only to the top portion of the vase and left to drip over a soft gray glaze (p. 98).

Following the principles of decorative design that placed a strong emphasis on plant forms, which had characterized much of the Rookwood Pottery ware, especially in the early decades, the Newcomb Pottery in New Orleans based its design ideas on plant life, primarily that native to the South. Unlike potteries such as Rookwood, which were artistic endeavors operating with a strong commercial base, Newcomb was essentially an educational enterprise. The pottery was part of the program of the H. Sophie Newcomb Memorial College, the female arm of Tulane University. Newcomb maintained important links with Rookwood. Rookwood provided the loosely followed model for the Newcomb

Pottery, whereby a staff of potters (usually men) actually formed the vessels, and another group (in Newcomb's case, invariably women students) decorated the ware. In addition, Mary G. Sheerer, who joined the Newcomb Pottery at its inception in 1894, was from Cincinnati, had studied at the Cincinnati Art Academy, and was associated with the early Rookwood decorators.

Early Newcomb ware featured stylized floral motifs, enhanced by incised and darkened lines. The iris was a favorite motif and appears in the Morse Museum example in the blue and blue-gray palette that remains typical of Newcomb work (p. 99). Like another vase in the collection whose plant form has been so geometricized as to render its botanical identification impossible (fig. 13), this vase is covered in a shiny, clear glaze, indicating that it dates to the early part of the pottery's production. After 1910, Newcomb introduced a dull, clear semi-mat glaze, seen in the squat vase with the ubiquitous Newcomb southern landscape of Live Oak trees draped with hanging moss and the full moon appearing through the trees (p. 101).

In the spirit of the Newcomb enterprise, a Boston club called Saturday Evening Girls was founded; it brought together a group of young women (in this case primarily immigrants living in Boston) to encourage craft activities. Pottery soon became the primary outlet for the group after its founder, Mrs. James J. Storrow, purchased a small kiln in 1906. Their pottery was named Paul Revere, suggesting the prevailing interest in the Colonial Revival and drawing specific attention to the patriot's fame in the Boston area. Like Newcomb wares, floral motifs dominated these works. The technique involved the use of heavily incised or black-painted borders filled in with flat areas of color, covered with a mat glaze. The results were often simplistic, but striking stylized designs of various blossoms, in this case tulips (p. 101). The simple designs were especially suited to children's sets, which became a staple of Paul Revere production. Although many of the pieces from this pottery bear the incised initials of their decorator, no roster of artists from the pottery has survived, and the artists remain unidentified.

The mat glazes favored by the women decorators at the Paul Revere Pottery were not new to the Boston area. William H. Grueby had previously developed at his Boston pottery thick mat glazes prone to veining or alligator-like cracking which had a significant impact on the development of artistic pottery in America. The vases that he introduced to the American public in 1897 were quite literally rooted in nature, in their relief-modeled designs of abstracted repeated leaf forms covering the entire surface of the vase (p. 102). The inspiration for such designs was admittedly borrowed from the work of French potter Auguste Delaherche, which Grueby had seen in 1893 at the World's Columbian Exposition in Chicago. Yet while the relief leafy designs were direct Delaherche translations, Grueby's glazes, which recalled the lush green colors of spring and summer foliage, were more immediately aligned with nature than were Delaherche's shinier glazes of blues, reds, and greens.

The Grueby Pottery also departed from the traditional organization of late nineteenth- and early twentieth-century potteries. Rather than employ female artists to decorate the vases, the designs at Grueby were conceived and drawn by men, led initially by architect George P. Kendrick (from 1897 to 1902), followed by Addison B. LeBoutillier

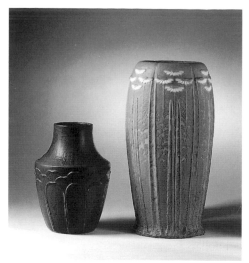

14

(from 1903 to 1911). The women at Grueby Pottery were employed merely to interpret Kendrick's and LeBoutillier's standardized designs. The pottery's designs achieve a decorative effect through severe stylization, here seen in the highly ordered daisies, depicted as half ovals, with the petals articulated in a linear mode, and repeated as the motif crowning a carefully orchestrated series of thin vertical leaves (fig. 14). Such stylization can also be seen in a vase to which has been added a metallic mount as a lamp base (p. 105), whereby tall thin stems with almond-shaped buds emerge between generously proportioned ovoid leaves. The verticality of the design is further emphasized by the vertical veins of the leaves in relief.

It is not surprising that Grueby pottery, with its strong affinities to the French work of Delaherche and Ernest Chaplet, received significant international exposure and attention. In fact, Grueby pottery may have been even better known in Europe than in America. It was shown at the 1900 Exposition Universelle in Paris, where it received three awards and where its mat glazes were deemed particularly noteworthy. At about the same time, Siegfried Bing began to represent Grueby's pottery at his gallery, L'Art Nouveau, in Paris.[28] Probably due to Bing's influence, examples of Grueby pottery were purchased by the Copenhagen Decorative Arts Museum and the South Kensington Museum (later the Victoria and Albert Museum) in London.

Published commentary on the Grueby display at the 1900 Paris exposition focused primarily on the special mat, lustreless glazes that the firm had perfected. In the jurors' report on the ceramics at the fair, these glazes were compared in highly favorable terms to those of Grueby's French counterparts, notably Alexandre Bigot, Eugène Baudin, and Raoul Lachenal. Although green was the dominant glaze color, the firm perfected other hues, including mustard, various shades of blue, and an oatmeal-colored ivory crackle glaze (pp. 106–7).

Grueby's mat green glazes would also have a significant impact on domestic Art Pottery production. Their popularity undoubtedly led William D. Gates to develop a variation for his own American Terra Cotta and Ceramic Company, in Terra Cotta, Illinois, just outside Chicago. Gates started in the pottery business making ornamental architectural

building materials out of terracotta as well as urns and garden ornaments for the landscape beautiful movement that was taking over the country. The vases that his firm began to produce in 1901, known by the acronym Teco, were designed by a number of architects working in the Chicago area, including such notable figures as Frank Lloyd Wright and William LeBaron Jenney. Gates, who had no architectural training, designed the majority of shapes made by his company. The stark simplicity of the example in the Morse Museum (p. 108), designed by Gates, reveals to great advantage the pottery's trademark smooth, silvery gray-green glaze. The vase was illustrated in two early catalogues issued by the pottery. In one dated 1905 and entitled *Hints for Gifts and Home Decoration*, it was described as "one of the handsomest decorative pieces ever modeled. The severe simplicity of its lines will commend it to all art lovers."[29] In their promotional catalogue published the following year, it was aptly called a "Super-classical vase" and sold for seven dollars.[30]

Mat glazes were also the specialty of the Hampshire Pottery, located in Keene, New Hampshire. Cadmon Robertson, a chemist and brother-in-law of the pottery's founder James Scholley Taft, was responsible for the wide array of mat glazes produced by the firm. Blue glazes, in varying and combined shades of gray and peacock blue, were among the most popular, as seen in the example illustrated (p. 109).

Like Grueby, Louis Comfort Tiffany's forays into pottery were linked to his interest in the avant-garde ceramics being made in France at the turn of the century. Tiffany saw the ceramics exhibited at the Paris Exposition Universelle of 1900, where he particularly admired the lustre pottery of Clément Massier, as well as the avant-garde work of Adrien-Pierre Dalpayrat, Auguste Delaherche, and Alexandre Bigot. Soon thereafter he was instrumental in bringing artistic French pottery to the attention of the American public in the exhibition he held at his Tiffany Studios showrooms in August 1901, where he displayed works by those who had exhibited in Paris the year before as well as works by Ernest Chaplet and Taxile Doat.[31]

Tiffany, although initially trained as a painter, had been working in a wide variety of decorative media since the late 1870s. Ceramics was the last medium he would take up, even though he had evinced an interest in it early on. He was an avid collector, amassing a sizable and eclectic collection that included pottery and porcelain from China and Japan, Hispano-Moresque lustreware from medieval Spain, and Native American pottery. His exposure to ceramics had begun even earlier, when he would observe the various vases and dinnerware, domestic and foreign, that were offered for sale at his father's shop, Tiffany & Co. When he established his own company and showrooms, they too became the venue for the display of foreign ceramics.

In late 1900, soon after Tiffany had returned from viewing the notable ceramics exhibitions in Europe, it was announced that he was beginning to experiment in the production of pottery.[32] Tiffany may not have been pleased with the initial experimental results, because it was not until 1904 that he introduced his new Favrile Pottery, at the Louisiana Purchase Exposition in St. Louis. The following year the pottery went into full production at the firm's furnaces in Corona, New York. By the end of that year, Tiffany & Co., the exclusive china, glass, silver, and jewelry firm founded by Tiffany's father, Charles, offered "Tiffany Favrile Pottery" in its *Blue Book*, the catalogue for preferred customers,

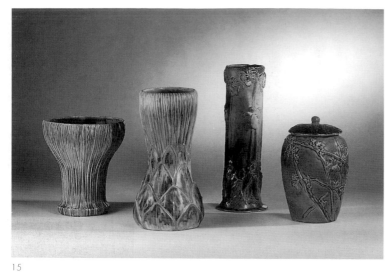

15

describing it as "entirely different from anything heretofore shown in table lamps, vases, jars and other pieces, now in process of manufacture."[33]

As was true for his work in glass, from the very beginning natural plant life informed Tiffany's work in pottery. A variety of plants and flowers, of the kind that Tiffany would have seen in the New York countryside, was treated sometimes in a conventional manner, but more often in a naturalistic style arranged for decorative effect. Many of the specific flowering plants had already found artistic expression in other media. For example, nasturtiums, tulips, fuchsias, cattails, and water lilies are motifs used on ceramics that Tiffany had previously interpreted in leaded-glass windows and lamp shades (pp. 112–13). Vegetables were less commonly used in Tiffany's other decorative designs, squash and eggplants, which appeared in some of his early windows, being the notable exceptions. However, such vegetal motifs as celery, artichokes, and pea pods provided appropriate subject matter for some of Tiffany's most effective pottery vases (fig. 15).

Like much of the Art Pottery made in the United States during the period, Tiffany's pottery was produced in molds, from which the shape and relief decoration were obtained. Each piece was then carefully finished by hand. In some cases, the molds for the pottery were taken directly from the vases and bowls that Tiffany Furnaces had produced in enamel on copper. The pottery version replicated the shape and design of the enamel-on-copper vessel, but in a slightly smaller size (p. 117). The discrepancy between the sizes of the vessels can be accounted for by slight shrinkage in the pottery during firing. Several general shapes found in Tiffany's enamels were utilized for his pottery as well: tall cylindrical vases; ovoid vases with flat, curved covers; and squat bowls with the rim turned over. Two cylindrical vases in the Morse Museum (p. 113), with relief decoration of fuchsias suspended from a branch placed asymmetrically on the form, represent the pottery interpretations of a form that also occurs in brilliantly colored enamel.[34] Another piece known to be an exact replica of an enamel vase is the tall bronze pottery vase with relief decoration of corn and corn stalks (p. 125).[35] It seems that once a mold was developed, if the shape continued to be approved by Tiffany, it remained in use throughout the relatively brief period that he was involved in pottery production. One

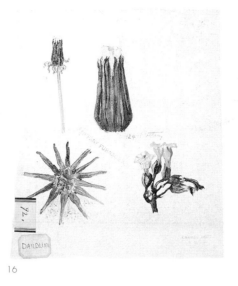

16

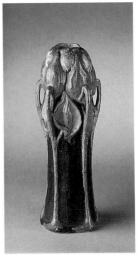

17

of the most daring designs that Tiffany employed for both enamel and pottery vases is the hollyhock vase (p. 118). The vase seems literally to support realistically portrayed hollyhock plants: due to an openwork design at the upper portion of the vase, the leaves of the plant make up the vase itself.

Further evidence that some of the designs used for Tiffany enamels were appropriated for pottery is the presence of a design drawing intended for enamelware in the Morse Museum that portrays the dandelion at various stages of bloom (fig. 16). The pencil inscription "Pottery" was added to one version of the flower. The drawing, which dates to about 1900, was probably executed by Alice Gouvy, who was hired about 1898 to work in the enameling studios.[36] Gouvy may have crossed media, turning from enamels to ceramics, the newer medium of the workshops. It is tempting to speculate that one intriguing vase in the Morse Museum may have been authored by Gouvy at the Tiffany Studios. With a milkweed plant depicted in relief around the vessel, the vase stands apart from other known Tiffany ceramics in the textural quality of its glaze, closely resembling the look of some Tiffany enamels (fig. 17). Furthermore, the piece bears the incised initials, AG, which likely refer to Alice Gouvy.

Tiffany was looking to the world of nature for inspiration for his designs, but he was also turning to the artistic pottery being produced in Europe at the time. One particular vase is an almost direct borrowing from a vase made by the Bing & Grondahl porcelain factory in Copenhagen, which was illustrated in the popular trade magazine of the day, *Keramic Studio*. The vase is composed entirely of a relief design of trillium flowers and foliage, with the leaves around the bulbous base, the stems along the attenuated neck, and the blossoms in irregular fashion at the upper edge (fig. 18). The vase appears here in a blue and green glaze as well as in a green-patinated bronze pottery. A variant of the form exists in a porcelain vase by Tiffany's fellow American ceramicist, M. Louise McLaughlin.[37]

The pottery vases were essentially multiples, having been formed through the use of molds. They became individual works of art by varying the glazes applied to the forms. It is not surprising that Tiffany focused equal, if not greater, attention on the finishes of his pottery. He had always been interested in surfaces, as evidenced in the extraordinary iridescent effects he achieved in his favrile glass. At one point, he even experimented with iridescent

fig. 16
Attributed to Alice Gouvy
Botanical Study—Dandelion.
c. 1900
Watercolor on paper
11¼ × 9¼ in.
Stamped on front: Tiffany
Furnaces/Enamel
Department/S.G. Co.,
pencil inscription:
124 Pottery

fig. 17
Vase, c. 1904
Alice Gouvy, designer
Tiffany Pottery, Corona,
New York (1904–c. 1914)
(p. 119)

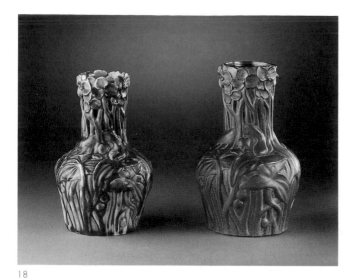

18

surfaces on pottery. One of the earliest citations of Tiffany's experiments in ceramics, reported that during his experimental stage, having been so inspired by the ceramics he had seen on exhibition at the Paris Exposition, "he came home with the determination to try it, and that he would probably produce something in the lustre bodies."[38] The unusual glazes found on contemporary European Art Pottery particularly impressed Tiffany. He attempted to replicate some of them. At the same time, he developed novel glazes of his own. During the first years of his pottery production, the glaze employed was creamy yellow in color with irregular highlights in olive green that helped reveal the relief decoration of the piece. The result has been compared to aged ivory (pp. 112–13).[39] By 1906, and probably the year before, the pottery had developed a new green glaze, undoubtedly in response, at least in part, to the popularity of the Grueby Pottery's mat green glazes. Of a decidedly different character than that found on the sober Grueby products, Tiffany's green glaze varied in tone from light to deep and in hue from a cool blue-green to one approaching chartreuse, sometimes several colors combining on one vase (pp. 111, 121). Crystalline effects were introduced which, in their likeness to lichen and moss found on the forest floor, heightened the naturalism of the vases. Such effects were possible because Tiffany used a high-fired, semi-porcelain body rather than a softer earthenware fired at a lower temperature.

Some vases were left entirely unglazed on their exteriors. It has been suggested that such vases were intended to be glazed to order. But some of these were glazed on the interior, making it more likely that Tiffany was aspiring to a different aesthetic effect. One remarkable example features stylized fern tendrils extending outward from the base and curving in to meet at the center (p. 122).

Tiffany's Bronze Pottery, introduced about 1910, also signaled a new aesthetic. It combined pottery and metal, retaining the shape of the pottery, but in most cases completely covering the exterior with a very thin metallic layer. The metal surface may have appealed to Tiffany because it could be patinated for varying surface effects. Some of these works have a warm brown surface color; others were finished in gold (pp. 124–27). The process involved electroplating a metal sheathing over the ceramic form. Many of the same

forms that had been in production earlier in pottery were then tried in the new Bronze Pottery technique.

In an unusual instance, Tiffany created a multimedia work, incorporating both bronze and his famed favrile glass on a pottery vessel. The vase in question, simple in form, with an allover moss-green glaze, received the additional embellishment of two bronze bands (one now missing), each inlaid with pieces of iridescent blue and gold favrile glass (p. 128).[40]

Tiffany's involvement with various glaze effects in pottery is consonant with his unwavering preoccupation with color. Works in the Morse Museum provide an unusual opportunity to view, side by side, examples of one form with distinctly varying glazes. The gourd-shaped vase with relief decoration in the form of pea pods appears in three different glaze treatments (p. 129): a glossy, pale-green transparent glaze revealing the ivory-colored body with dark green pooling of the glaze in the low-relief areas; a similar glaze with deeper olive green areas, yet here treated chemically to give it a mat finish; and a glaze incorporating ivory, green, black, and red, similar to one perfected in French pottery by Adrien-Pierre Dalpayrat. Another such grouping features three shallow bowls with subtle relief decoration of fish swimming in waves (pp. 130–31). Here the contrasts are even greater. One example is glazed only on the interior, leaving the exterior in the stark cream color of the body. The second bowl is of Bronze Pottery, with a patination resulting in a greenish gold finish. The third is the most unusual of the three and unusual in all of Tiffany's work. The heavy glaze is white with splotches of blue, pink, and green running toward the base. A heavy crackle is evident in some of the more thickly glazed white areas. Perhaps the most striking variations appear in a group of four large vases of a simpler and bolder form, probably inspired by Oriental pottery and porcelain (pp. 132–33). The size and simple surface show the glazes to advantage. They vary from a mossy pale-green glaze shading to yellow, to a mottled sandy-colored smooth glaze, to a glossy marine blue glaze with ivory color at the base, to a semi-mat glaze in gray with splotches of blue and black. The green-glazed vase was marked "A-Coll.," indicating that it was retained for Tiffany's personal collection. It should be noted that of the seven examples of pottery in the Morse collection marked "A-Coll." only one has relief decoration.[41] The other examples are simple forms, their primary interest being the glazes they feature (p. 135).

Like Tiffany's favrile glass vases and enamel vessels, his pottery was usually identified as being the product of Louis Comfort Tiffany. A new standard mark was introduced for the pottery, consisting of Tiffany's initials conjoined in a decorative cipher, which was incised into the base of the piece. Sometimes the words "Favrile Pottery" or "Favrile Bronze Pottery" would also be added. Again, as was common in his studio practices, Tiffany maintained a somewhat inconsistent numbering system for his pottery. Two-, three-, and four-digit numbers were also engraved into the bottoms of the pieces. Although no records survive to explicate the system, it is likely that it was sequentially conceived, a supposition borne out by the few objects that can be specifically dated. A new numbering series was initiated for the Bronze Pottery, generally a three-digit number preceded by the letters BP. It appears that the pieces Tiffany wanted set aside for his own collection, indicated by the "A-Coll." designation, were given their own numbering sequence. A large

number of the Tiffany pottery vessels bear an incised 7 or L on the bottom, the significance of which has yet to be determined. It is possible that it may refer to a particular kind of clay body.

Compared to the prolific Tiffany output in virtually every area of his operations except enamels,[42] the pottery production was somewhat limited. Its commercial success may also have been far more limited. The known recorded numbered examples barely surpass fifteen hundred.[43] Adding to a generous estimate of five hundred examples of Bronze Pottery, we arrive at a total of about two thousand pieces of pottery made by the Tiffany Studios. Of these, Tiffany retained at least eighty-four examples, which remained at Laurelton Hall until its contents were sold in 1946.[44] That number does not reflect a collection of forty-one favrile pottery tiles, described as "square and oblong . . . with molded floral and dragon ornament, on variously colored grounds, 2 to 4 inches square."[45] The production of pottery lasted barely a decade and probably ceased about 1914, and unquestionably before Louis Tiffany retired from the firm in 1919.

Experimentation with various glazes was a phenomenon that occurred at numerous art potteries around the country during the late nineteenth and early twentieth centuries. Grueby was a leader in promoting his mat green glaze, beginning in 1897. Artus Van Briggle, one of the key artists working at the Rookwood Pottery, began experimenting with mat glazes at about the same time. The unusual flambé glazes and sensitive mat glazes inspired by the Chinese and executed by such French potters as Ernest Chaplet and Auguste Delaherche undoubtedly provided the stimulus for his endeavors, since he began his experimentation shortly after an extended trip to Paris.[46] Van Briggle's experiments yielded to success in 1898.[47] It was in that year that he produced a sculptural vase, a radical departure for Rookwood, which was the prototype for the now-famous "Lorelei" vase. The piece has an allover mat glaze in a soft blue-green, tinged with gray.[48] This work was not only the beginning of Van Briggle's trademark work of sculptural vessel forms sheathed in tactile mat finishes in rich colors, but it also represented a new departure for Rookwood—one that would become a mainstay of the pottery through the next several decades. However, ill health prevented Van Briggle from pursuing this further in Cincinnati, and he resigned from the pottery in 1899, moving to the restorative climate of Colorado Springs to begin a pottery bearing his own name. At his Van Briggle Pottery, he and his wife, Anne, went on to develop velvety mat glazes, beyond greens and blues, to a broad array ranging from yellow golds, to browns, to deep roses and purples. The glazes were applied with an atomizer, which enabled the staff to develop subtle shading from one color to another. Artus Van Briggle died at the young age of thirty-five in 1904. His wife carried on with the pottery and directed and expanded the works. The firm, which continues in operation to this day, shifted to Art Pottery on a mass-produced scale. Many of the later commercial art wares recall the early low-relief designs of stylized plant motifs. New shapes were also introduced well into the twentieth century, such as a large vase with three Native American heads in high relief (p. 138). In a promotional gift brochure issued by the pottery, probably in the 1920s or 1930s, the "Indian Chief" vase, as it was called, was illustrated as a lamp base with a shade adorned with butterflies, also produced by the pottery.[49]

Another distinct glaze treatment was the elusive and seductive crystalline glaze, whereby crystals were introduced into the glaze by means of mineral salts. In 1884 the Rookwood Pottery had accidentally discovered a type of crystalline glaze, which they christened Tiger Eye, after its resemblance to that stone. In one example, shimmering gold crystals on what Rookwood termed its Mahogany glaze are viewed through a translucent yellow-tinted, shiny transparent glaze. The glaze could not be replicated at will, and its success ratio at the pottery was less than one in a hundred.[50] Equally elusive was Rookwood's Goldstone glaze, which also first appeared in 1884. In it, masses of tiny gold flecks are captured on the Mahogany glaze vessel. Due to their risky production and high percentage of loss, both the Tiger Eye and the Goldstone glazes appear most often on small pieces, not larger than 6 inches tall (pp. 139, 140).

Aside from these Rookwood "accidents," crystalline glazes did not capture the imagination of American potters until they saw the unusual glazes exhibited at the 1900 Paris Exposition Universelle by potters from France, Denmark, Sweden, Germany, and Belgium. The jewel-like, lively attributes of the glazes were a welcome contrast to the sober, heavy mat glazes also being produced at the time. Teco introduced its first crystalline glazes in 1902. These were microcrystalline in structure, and the tiny crystals are barely seen within the overall glaze. By contrast, Adelaide Alsop Robineau, employing techniques perfected by Sèvres ceramicist Taxile Doat, developed an array of crystalline glazes that featured beautiful blossomlike crystals on a variety of softly colored backgrounds (fig. 19). Robineau was a pioneer figure, who began her career in china painting before embarking on the exacting medium of porcelain in a small-scale studio operation at her home in Syracuse, New York. Her path in this endeavor was cleared by M. Louise McLaughlin's early experiments in the medium, called "Losanti" (p. 140). Robineau's influence extended far beyond the highly wrought carved works she created with extreme patience and skill. She and her husband published the important trade magazine *Keramic Studio*. She also joined Doat and Frederick Hurton Rhead, another noted potter at the time, in an innovative school of ceramics at University City, near St. Louis, in 1910.

Mary Chase Perry (Stratton) was another figure whose early career began in the china painting movement of the late nineteenth century; it evolved in 1903 into the founding of her own pottery in Detroit, called the Pewabic Pottery. The shapes of her wares were exceedingly simple, based on Oriental forms, perhaps influenced by her friendship with collector Charles Lang Freer, an early supporter of the pottery. The glazes she developed were rich in color and interest: flowing glazes in red, green, gold, purple, and blue were combined and, when fired, achieved various iridescent and lustre effects (p. 142). These were probably influenced by twelfth- and thirteenth-century examples from Persia and Syria that were beginning to be collected in America from the time of the 1893 World's Columbian Exposition.[51]

The factory that most extensively exploited crystalline effects was the Fulper Pottery in Flemington, New Jersey. Like Teco and several of the Cincinnati potteries, the Fulper Pottery had been an established manufacturer of utilitarian earthenwares prior to the introduction of art wares. In late 1909, Fulper brought out a line of Art Pottery, called Vasekraft. The forms were robust and solid, sometimes recalling Chinese shapes. But their

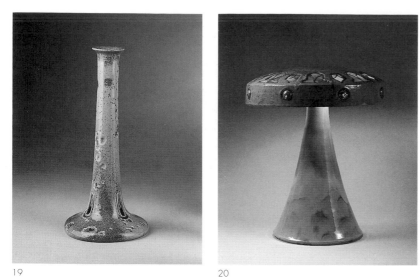

19

20

chief attraction was the rich, many-hued crystalline glazes in shades of rose, green, blue, and brown (pp. 143–44). Among the most remarkable achievements of the Fulper Pottery were the pottery lamps, whereby simple, usually conical, bases were fitted with slightly domed shades, also of glazed pottery, and inset with small panes of colored opalescent glass. A unique technical innovation introduced in 1912, the lamps are among the most avant-garde of all Fulper products. Some, like that in the Morse Museum (fig. 20), termed a "Funnel Lamp" in Fulper's promotional literature[52] and glazed in a thick, flowing glaze of light tawny brown, resemble the natural form of a mushroom.

Glowing iridescent effects, evocative of Louis Comfort Tiffany's favrile glass, were produced by the French potter Jacques Sicard at the Weller Pottery in Zanesville, Ohio (p. 67), better known for its commercial copies of Rookwood Pottery. Sicard had been associated with Clément Massier of Golfe Juan, France, and he was soon producing vessels in America with painted designs of a rainbow metallic lustre (p. 146). The Sicard line featured floral patterns in lustrous gold, purple, and blue, and was produced for only a limited time at the Weller factory, from about 1902 until 1907, when Sicard returned to France.

As seen through the representative examples in the collection of The Charles Hosmer Morse Museum of American Art, American Art Pottery offers an impressive richness and variety in aesthetic effect through form and surface. The potteries in operation during the late nineteenth and early twentieth centuries employed the full range of ceramic techniques available for clay bodies, production, painted and molded decoration, and glazes. Many innovations in decoration and production were developed during the period. The artists in the ceramic medium drew upon examples that were becoming available to them from the Far and Near East. They also mined the contemporary ceramic work being produced in Europe at the time. And their work reveals an intense interest in color and in nature. The result enhances our aesthetic appreciation and celebrates the ingenuity, individuality, and skill of potters working in America a century ago.

NOTES

1. For a thorough discussion of books on landscaping and gardens published or reprinted in the United States during the period, see Elizabeth Woodburn, "Addendum [of Books Published from 1861–1920]," in U.P. Hendrick, *A History of Horticulture in America to 1860,* rev. ed. (Portland, Ore.: Timber Press, 1988), pp. 557–81. For a study of public and private gardens of the day, see Mac Griswold and Eleanor Weller, *The Golden Age of American Gardens* (New York: Harry N. Abrams, 1992).

2. Mrs. S.O. Johnson, *Every Woman Her Own Flower Gardener* (1871), quoted in Hendrick, *A History of Horticulture,* pp. 567–68.

3. When the contents of Laurelton Hall were sold at auction in 1946, plants and gardens accounted for the subject matter of more books than any other in the inventory. Over seventy-five single and multi volume works were listed in the auction catalogue; see *Objects of Art of Three Continents and Antique Oriental Rugs: The Extensive Collection of the Louis Comfort Tiffany Foundation,* sales cat. (New York: Parke-Bernet Galleries, September 24–28, 1946), lots 622–23, 630–37, 647, 667, 669, 680–81, 706.

4. William C. Prime, *Pottery and Porcelain of All Times* (New York: Harper & Brothers, 1878), pp. 420–21.

5. "Rookwood Record Shape Book," Cincinnati Historical Society.

6. Ibid.

7. Ibid.

8. The number of women engaged in china painting may be even higher. One periodical aimed at a china-painting audience, entitled *The Artist,* boasted as its motto in 1915: "A Million Women Making and Painting CHINA by 1920"; see *The Artist* (Chicago), 2 (October 1915), p. 1.

9. Jennie J. Young, *The Ceramic Art: A Compendium of the History and Manufacture of Pottery and Porcelain* (New York: Harper & Brothers, 1878), p. 291.

10. Ibid., p. 296.

11. Several of the students enrolled in Wheatley's pottery decorating class at the Coultry Pottery went on to have distinguished careers of their own in Art Pottery. These included John and Martin Rettig, Albert R. Valentien, Matthew A. Daly, and Clara Newton, who became accomplished decorators at the Rookwood Pottery.

12. Tradition has it that Maria Longworth Nichols was invited to become a member of the Pottery Club in Cincinnati, but the invitation never reached her. Taking offense at the apparent slight, she thereafter refused to join the club.

13. Illustrations from Hokusai's *Manga* provided an important design source for many Rookwood decorators during the early 1880s. This fifteen-volume work featured a plethora of pictures of Japanese plants and flowers, fish, animals, imaginary creatures, and people.

14. For example, the wide-mouthed vase decorated by Cora Crofton (p. 41), with pale pink and cream-colored five-petaled apple blossoms on a branch descending diagonally from the lip, is virtually the identical composition on the same shape vase executed by Albert R. Valentien, c. 1881. However, the same flowers on the Valentien version are stark white with olive leaves on a mottled gray ground. See Martin Eidelberg, ed., *From Our Native Clay: Art Pottery from the Collections of the American Ceramic Arts Society,* exh. cat. (New York: American Ceramic Arts Society, 1987), p. 22, ill. 17.

15. "Rookwood Shape Record Book" records four entries as having been modeled after "Nancy ware," referring to Gallé's ceramics made in Nancy, France. Rookwood copied the Gallé pieces from examples procured by Robert H. Galbreath, principal agent for Duhme and Company, a luxury retail establishment in Cincinnati; see Kenneth R. Trapp, "Rookwood and the Japanese Mania in Cincinnati," *The Cincinnati Historical Society Bulletin,* 39 (Spring 1981), pp. 59–60.

16. Montezuma [Matt Morgan], *Art Amateur,* 11 (June 1884), p. 4.

17. Morgan exhibited his new art wares at the Bartholdi Loan Exhibition in New York in February of 1884; see Mary Gay Humphreys, "Cincinnati Pottery at the Bartholdi Exhibition," *Art Amateur,* 10 (February 1884), p. 69.

18. For an in-depth discussion of the precise date of Fry's development of the technique and her subsequent patent application and issuance, see Anita J. Ellis, *Rookwood Pottery: The Glorious Gamble,* exh. cat. (Cincinnati: Cincinnati Art Museum, 1992), p. 58 nn. 6, 7.

19. Kenneth R. Trapp, *Ode to Nature: Flowers and Landscapes of the Rookwood Pottery, 1880–1940,* exh. cat. (New York: Jordan-Volpe Gallery, 1980), p. 26.

20. During Valentien's eight-month trip to California in 1903, he painted 130 specimens of California plants. Of these renderings, 144 are in the Cincinnati Art Museum. See Trapp, *Ode to Nature,* pp. 26–27, 62.

21. For the iconography of this vase, see Ellis, *Rookwood Pottery,* p. 75.

22. Ibid., pp. 80–83.

23. Ibid., p. 16.

24. Albert R. Valentien, "Rookwood Pottery," c. 1910, unpublished paper, n.p., in Trapp, *Ode to Nature,* p. 30.

25. S. Bing, *La culture artistique en Amérique* (1895), trans. by Benita Eisler as *Artistic America: Tiffany Glass and Art Nouveau,* ed. Robert Koch (Cambridge, Mass.: MIT Press, 1970), pp. 170, 177.

26. Ibid., p. 248.

27. See Kenneth R. Trapp, "Rookwood Pottery: The Glorious Gamble," in Ellis, *Rookwood Pottery,* pp. 32–33.

28. Susan J. Montgomery, *The Ceramics of William H. Grueby: The Spirit of the New Idea in Artistic Handicraft* (Lambertville, N.J.: Arts & Crafts Quarterly Press, 1993), p. 38.

29. The Gates Pottery, *Hints for Gifts and Home Decoration* (Terra Cotta, Ill.: Gates Pottery, 1905), p. 4.

30. The Gates Pottery, *Teco Pottery/America* (Terra Cotta, Ill.: Gates Pottery, 1906), n.p., no. 72. An original of this catalogue is in the collection of the Erie Art Museum, Pennsylvania.

31. Anna B. Leonard, "Exhibition of French Pottery at the Tiffany Studios," *Keramic Studio,* 3 (August 1901), pp. 82–83.

32. [Adelaide Alsop Robineau], editorial, *Keramic Studio,* 2 (December 1900), p. 161.

33. *Tiffany and Company's Blue Book* (New York: Tiffany & Co., 1906), p. 459.

34. For an illustration of the vase, see Janet Zapata, *The Jewelry and Enamels of Louis Comfort Tiffany* (New York: Harry N. Abrams, 1993), p. 52, fig. 17.

35. The enamel-on-copper corn vase is in The Metropolitan Museum of Art (acc. no. 1981.444). For a published illustration, see Zapata, *Jewelry and Enamels of Louis Comfort Tiffany*, p. 50, fig. 10.

36. See Himilce Novas, "A Jewel in His Crown," *Connoisseur*, 213 (October 1983), p. 135; see also Zapata, *Jewelry and Enamels of Louis Comfort Tiffany*, pp. 48, 57–59.

37. McLaughlin's vase was illustrated in a group photograph of her Losanti porcelain ware in "Losanti Ware," *Keramic Studio*, 3 (December 1901), pp. 178–79; see also Mrs. Monachesi, "Miss M. Louise McLaughlin and Her New 'Losanti Ware,'" *The Art Interchange*, 48 (January 1902), p. 11.

38. [Adelaide Alsop Robineau], editorial, *Keramic Studio*, 2 (December 1900), p. 161.

39. The three vases that Tiffany exhibited at the Louisiana Purchase Exposition, St. Louis, in 1904 bore an ivory-colored glaze, as did the four vases that he sent to an exhibition of the New York Keramic Society in April of that year. Further evidence that the ivory glaze predates Tiffany's other glazes is the fact that of those vases that bear incised numerals, probably production numbers of some kind, the earliest numbers appear almost exclusively on examples with the ivory glaze.

Tiffany's careful attention to finishes and to replicating the look of an antique is consistent with his aesthetic in other media. For example, in furniture he designed and had made for the music room of two of his most important patrons, Louisine and H.O. Havemeyer, a laborious finishing process was undertaken to "make it look old and as if it had been handled for many years. . . . When finished it did have the quality of the old ivory inro"; see Louisine W. Havemeyer, *Sixteen to Sixty: Memoirs of a Collector* (New York: privately published, 1961), p. 11.

40. Tiffany also incorporated favrile glass into a Bronze Pottery vessel now in the Cooper-Hewitt Museum, New York, in which six iridescent amber favrile glass scarabs were mounted into the shoulder of the vase; see *American Art Pottery* (New York: Cooper-Hewitt Museum, Smithsonian Institution's National Museum of Design, 1987), no. 56, p. 103.

41. Although none of the Tiffany favrile pottery vases in Tiffany's collection at Laurelton Hall is illustrated in the 1946 auction catalogue of the house's contents (see note 3), even the sketchy descriptions indicate only five of the eighty-four examples enumerated had molded decoration.

42. It has been estimated that approximately 750 enamels were produced by the Tiffany Studios in just over nine years, from 1898 until 1907; see Zapata, *Jewelry and Enamels of Louis Comfort Tiffany*, p. 46.

43. The highest number in the Morse Museum collection, and the highest recorded number known to the author, is 1,554 (see acc. no. 78-14).

44. See *Objects of Art . . . of the Louis Comfort Tiffany Foundation*, lots 78–99.

45. Ibid., lot 99.

46. For more information on the early work of Van Briggle, see Eugene Hecht, "Artus Van Briggle: The Formative Years," *Arts & Crafts Quarterly*, 1 (January 1987), pp. 1, 7–12.

47. See "Van Briggle Pottery," *The Clay-Worker*, 43 (May 1905), pp. 645–46.

48. For an illustration and description of the vase, see Wendy Kaplan, *"The Art That Is Life": The Arts & Crafts Movement in America, 1875–1920*, exh. cat. (Boston: Museum of Fine Arts, 1987), no. 40, p. 154.

49. *Van Briggle Art Pottery: The Gift Superb* (Colorado Springs: Van Briggle Art Pottery, n.d.), n.p. The original catalogue is in the Winterthur Library, H.F. du Pont Winterthur Museum, Delaware.

50. Ellis, *Rookwood Pottery*, p. 47.

51. See Alice Cooney Frelinghuysen, "The Forgotten Legacy: The Havemeyers' Collection of Decorative Arts," in Alice Cooney Frelinghuysen, Gary Tinterow, et al., *Splendid Legacy: The Havemeyer Collection* (New York: Metropolitan Museum of Art, 1993), pp. 108–10. For an example of Syrian pottery (Rakka ware) in Freer's collection that Mary Chase Perry probably knew, see Thomas Lawton and Linda Merrill, *Freer: A Legacy of Art* (Washington, D.C.: Freer Gallery of Art, Smithsonian Institution, 1993), p. 112, fig. 75. A three-handled vase, presumably Pewabic Pottery, which can be seen in a 1909 photograph of Freer (ibid., frontispiece), is remarkably similar to the Rakka example.

52. [Advertisement], *The Fra*, 4 (December 1909), p. xiv, in Robert W. Blasberg with Carol L. Bohdan, *Fulper Art Pottery: An Aesthetic Appreciation, 1909–1929*, exh. cat. (New York: Jordan-Volpe Gallery, 1979), p. 64.

CATALOGUE

∎

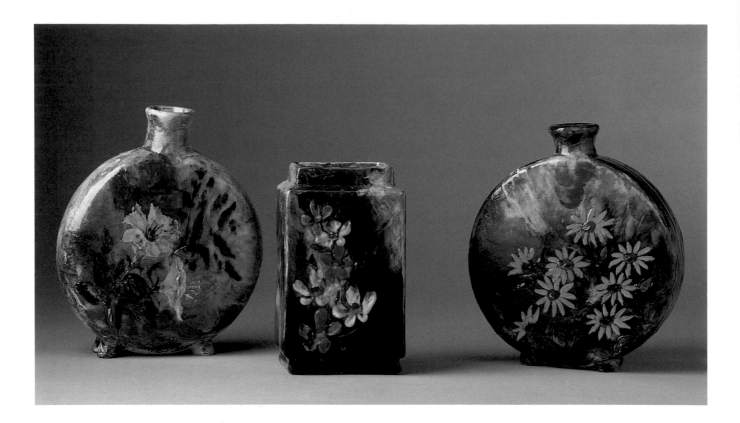

■

Vase, 1880

Coultry Pottery, Cincinnati (1874–83)
Glazed white clay, h. 8¼ in.
Marks: R-V/1880 (incised);on front lower left: MWC (glazed)
Gift of Herbert O. and Susan C. Robinson PO-129-86

■ ■

Vase, 1880 **Vase, 1880**

T.J. Wheatley & Company, Cincinnati (1880–82) T.J. Wheatley & Company, Cincinnati (1880–82)
Glazed yellow clay, h. 8¼ in. Glazed yellow clay, h. 6¾ in.
Marks: T.J.W. & Co./Pat Sep 28/1880 (incised) Marks: TJW & Co/Pat Sep 28/1880 (incised)
PO-1-72 Gift of Herbert O. and Susan C. Robinson PO-127-86

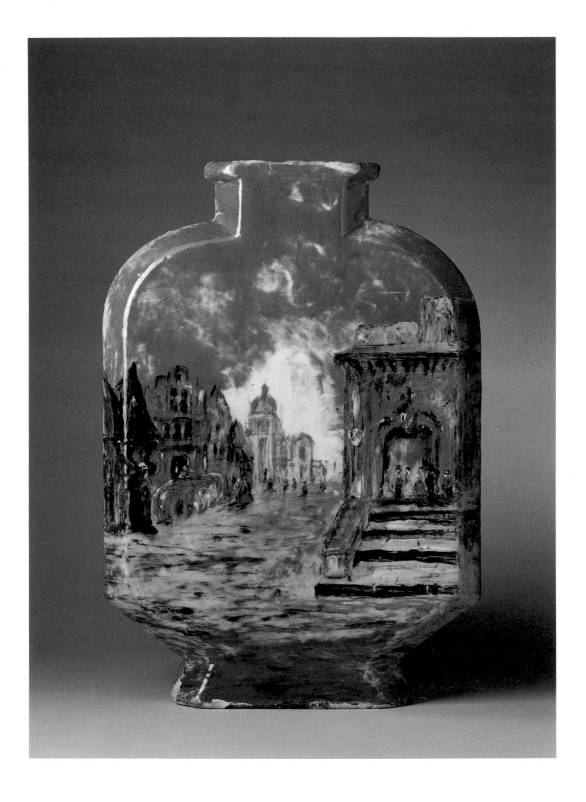

■

Vase, 1879

Thomas Jerome Wheatley (1853–1917), Cincinnati
Glazed yellow clay, h. 18 in.
Marks: T.J. Wheatley, Cincinnati 1879 (incised)
PO-5-70

■

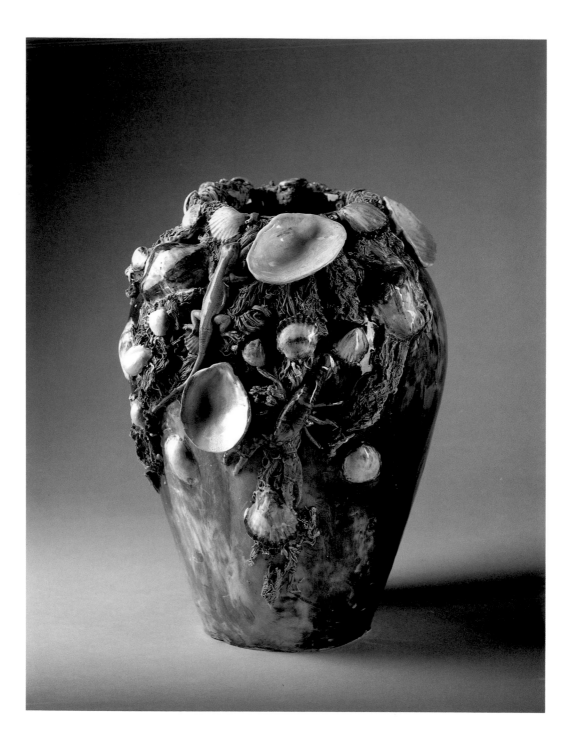

Vase, c. 1880–82

T.J. Wheatley & Company, Cincinnati (1880–82)
Glazed white clay, h. 11¾ in.
Unmarked
PO-90-94

■

Cuspidor, 1882

Nicholas Joseph Hirschfeld (1860–1927), decorator
Rookwood Pottery, Cincinnati (1880–1967)
Red clay, h. 7¾ in.
Marks· Rookwood 1882 (impressed); NJH (incised)
PO-7-66

■

Vase, 1882

Maria Longworth Nichols (1849–1932), decorator
Rookwood Pottery, Cincinnati (1880–1967)
Glazed ginger clay, h. 9½ in.
Marks: Rookwood 1882/G 102 (impressed); MLN (incised)
PO-17·68

■

Tea Jar, 1883

Matthew A. Daly (1860–1937), decorator
Rookwood Pottery, Cincinnati (1880–1967)
Glazed ginger clay, h. 5½ in.
Marks: Rookwood 1883/anchor mark/97 (impressed); MAD (incised)
PO-34-65A, B, C

39

■

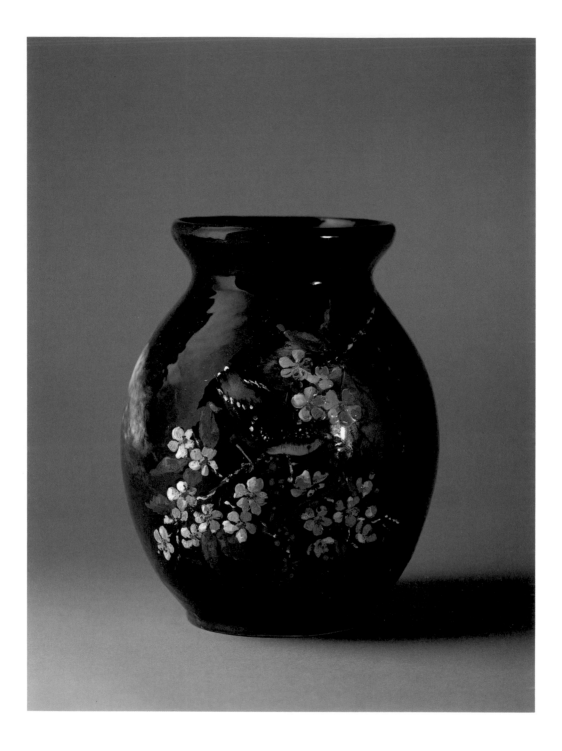

■

Vase, 1882

Albert Humphreys, decorator
Rookwood Pottery, Cincinnati (1880–1967)
Glazed yellow clay, h. 11¼ in.
Marks: Rookwood 1882/anchor mark (impressed); A.H. (incised)
Gift of Herbert O. and Susan C. Robinson PO-142-86

■

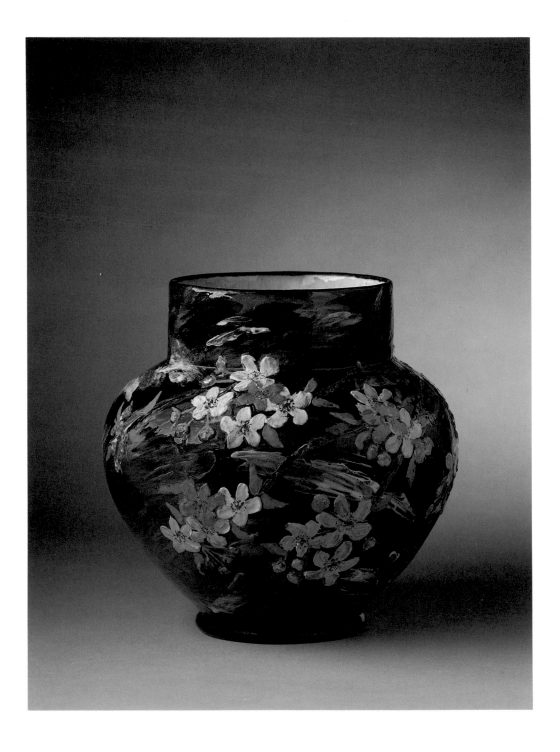

Vase, 1882

Cora Crofton, decorator
Rookwood Pottery, Cincinnati (1880–1967)
Glazed yellow clay, h. 10½ in.
Marks: Rookwood 1882 (impressed); C (incised)
Gift of Herbert O. and Susan C. Robinson PO-52-68

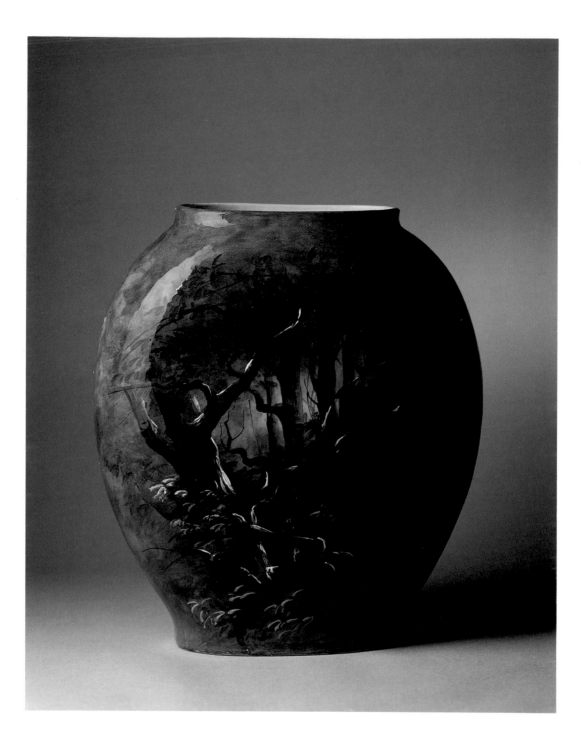

■

Vase, 1883

Albert R. Valentien (1862–1925), decorator
Rookwood Pottery, Cincinnati (1880–1967)
Glazed ginger clay, h. 14½ in.
Marks: Rookwood 1883/125/G (impressed); ARV (incised)
PO-53-68

.

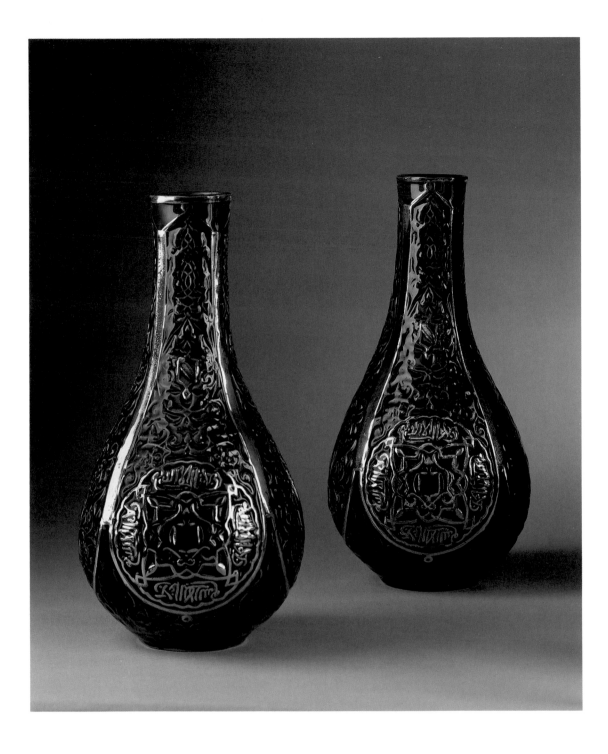

■

Pair of Vases, c. 1884

Matt Morgan Art Pottery, Cincinnati (1882–84)
Glazed faience, h. 11¾ in.
Marks: Matt Morgan Art Pottery Co/234 (impressed);
second vase unmarked
PO-114-1, PO-2-81

·

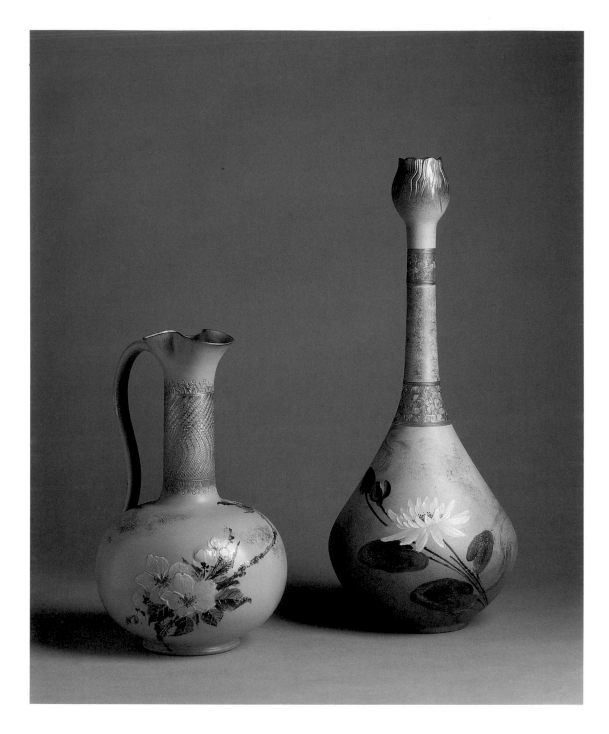

■

Claret Jug, 1887

Matthew A. Daly (1860–1937), decorator
Rookwood Pottery, Cincinnati (1880–1967)
Glazed yellow clay, h. 11⅜ in.
Marks: Rookwood logo surmounted by one flame/101 A/Y/M.A.D.
(impressed)
Gift of Herbert O. and Susan C. Robinson PO-45-84

■

Vase, 1885

Matthew A. Daly (1860–1937), decorator
William Watts Taylor (1847–1913), designer
Rookwood Pottery, Cincinnati (1880–1967)
Glazed yellow clay, h. 17½ in.
Marks: 238/Rookwood 1885/Y (impressed); MAD (painted in gold)
Gift of Herbert O. and Susan C. Robinson PO-69-93

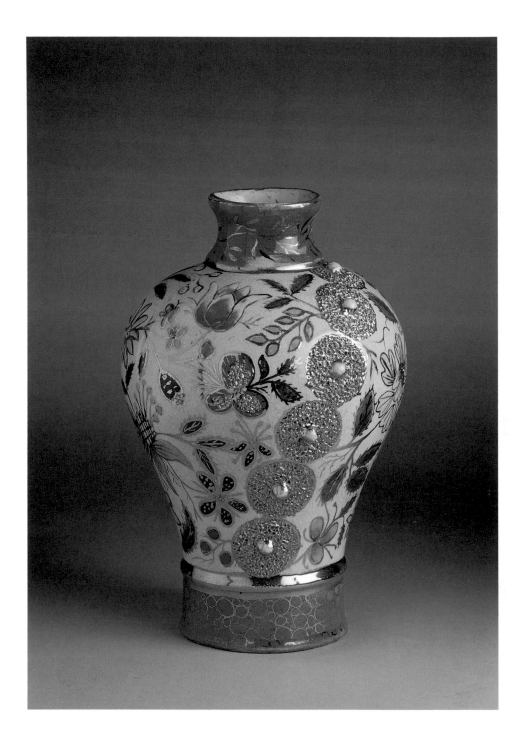

■

Vase, 1887

Marie Evans, decorator
Cincinnati Art Pottery (1880–91)
Glazed white clay, h. 10 in.
Marks: Marie Evans/Cin O/1887 (incised)
Gift of Herbert O. and Susan C. Robinson PO-12-88

■

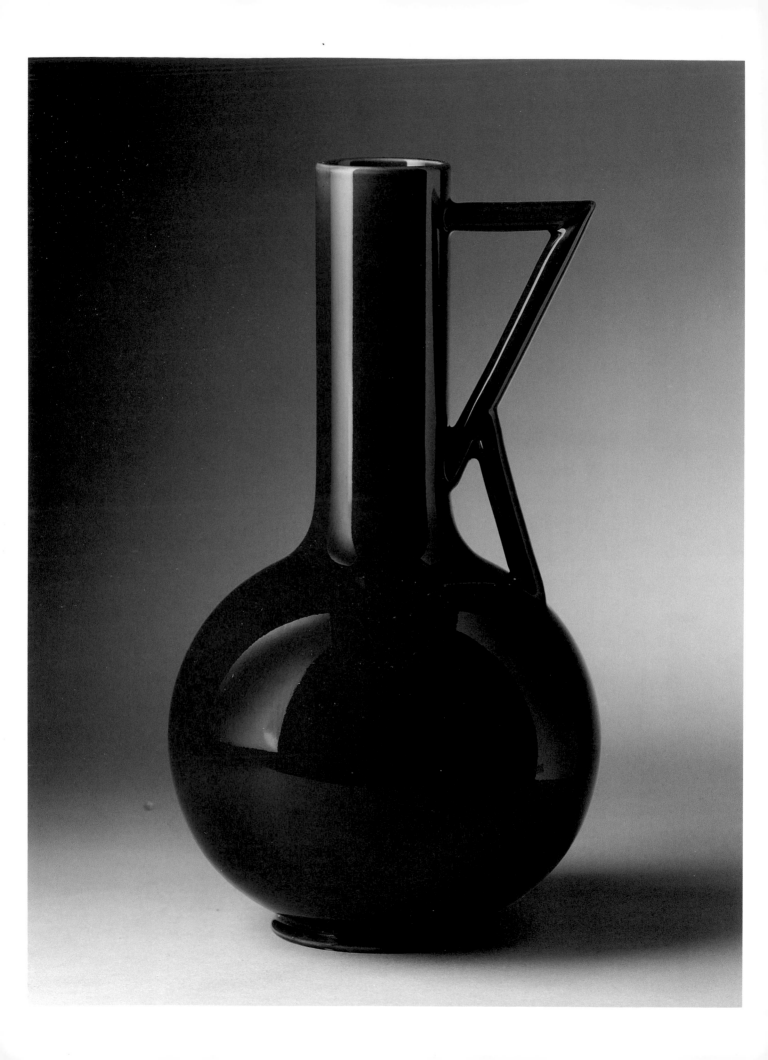

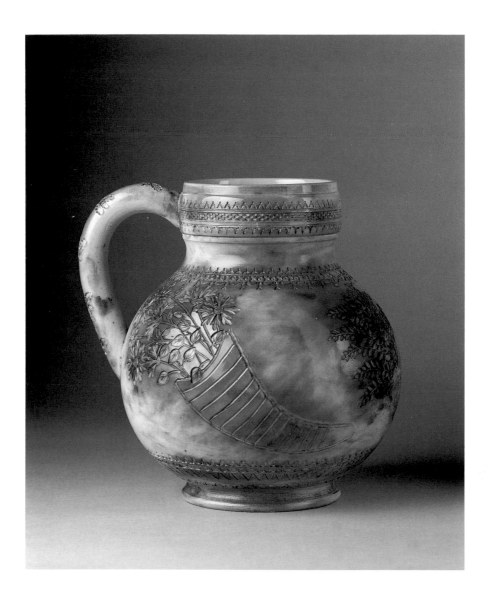

Pitcher, 1882

Rookwood Pottery, Cincinnati (1880–1967)
Glazed white clay, h. 12¼ in.
Marks: Rookwood 1882/W/26 (impressed)
PO-54-68

Pitcher, 1882

Fannie Auckland (1868–1945), decorator
William Auckland, potter
Rookwood Pottery, Cincinnati (1880–1967)
Glazed gray clay, h. 7½ in.
Marks: Rookwood 1882 (impressed); F.A. (glazed)
Gift of Herbert O. and Susan C. Robinson PO-139-86

Jug, 1884

Edward Pope Cranch (1809–1892), decorator
Rookwood Pottery, Cincinnati (1880–1967)
Glazed ginger clay, h. 6½ in.
Marks: Rookwood 1884/G/85/Cranch (impressed)
PO-46-66

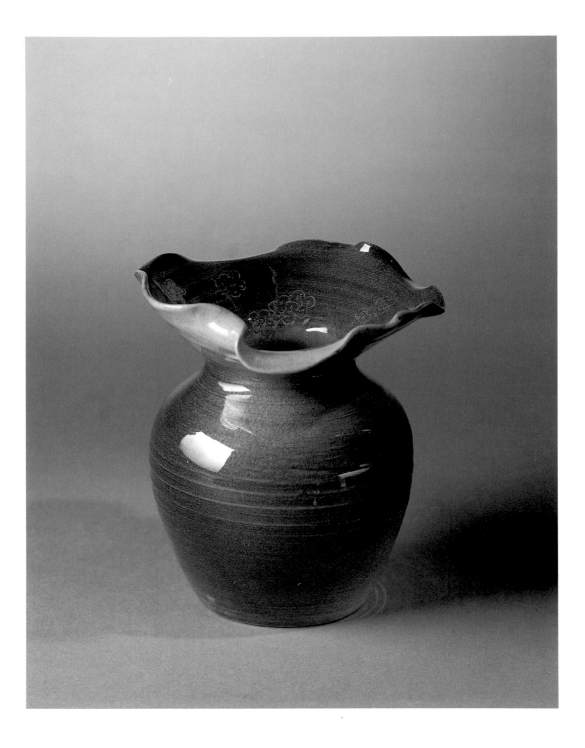

■

Vase, 1886

Anna Marie Bookprinter (1862–1947), decorator
Rookwood Pottery, Cincinnati (1880–1967)
Glazed sage green clay, h. 5⅝ in.
Marks: Rookwood 1886/S/278 C (impressed); A.M.B (incised)
PO-26-70

·

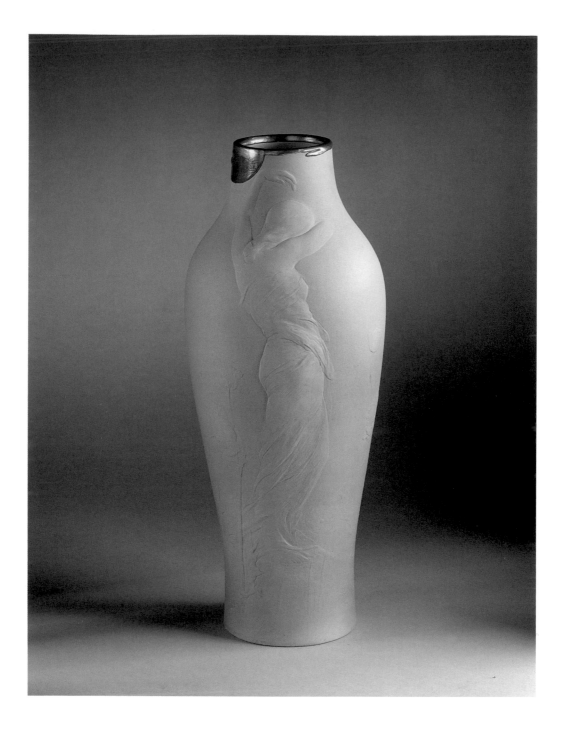

Vase, 1899

Harriet Elizabeth Wilcox, decorator
Rookwood Pottery, Cincinnati (1880–1967)
Glazed white clay with metal overlay, h. 14¾ in.
Marks: Rookwood logo surmounted by thirteen flames/879 B
(impressed); H.E.W./Garden of Eden (incised)
PO-6-92

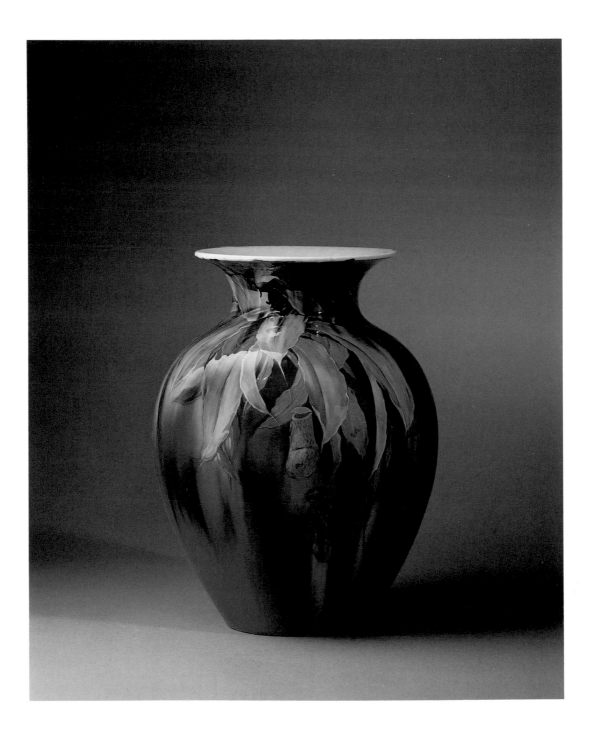

■

Vase, 1890

Albert R. Valentien (1862–1925), decorator
Rookwood Pottery, Cincinnati (1880–1967)
Glazed white clay, h. 11¼ in.
Marks: Rookwood logo surmounted by four flames/488/F/W
(impressed); A.R.V./L (incised)
PO-59-66

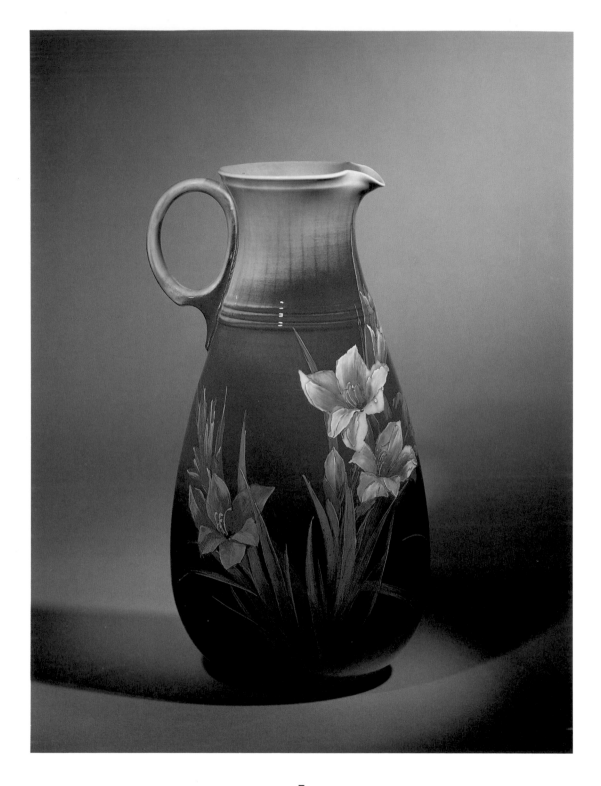

■

Pitcher, 1891

Matthew A. Daly (1860–1937), decorator
Rookwood Pottery, Cincinnati (1880–1967)
Glazed white clay, h. 12¼ in.
Marks: Rookwood logo surmounted by five flames/567/W
(impressed); MAD/L (incised)
PO-21-66

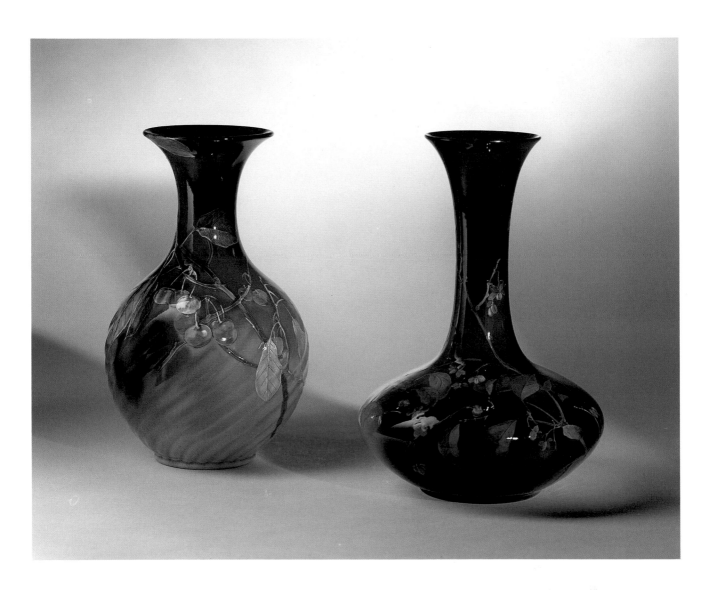

Vase, 1892

Artus Van Briggle (1869–1904), decorator
William Watts Taylor (1847–1913), designer
Rookwood Pottery, Cincinnati (1880–1967)
Glazed white clay, h. 11 ⅞ in.
Marks: Rookwood logo surmounted by
six flames/653/W (impressed)
PO-57-67

Vase, 1895

Robert Bruce Horsfall (1869–1948), decorator
William Watts Taylor (1847–1914), designer
Rookwood Pottery, Cincinnati (1880–1967)
Glazed white clay, h. 12 ⅛ in.
Marks: Rookwood logo surmounted by
nine flames/468 A (impressed); B— (incised)
Gift of Herbert O. and Susan C. Robinson PO-62-70

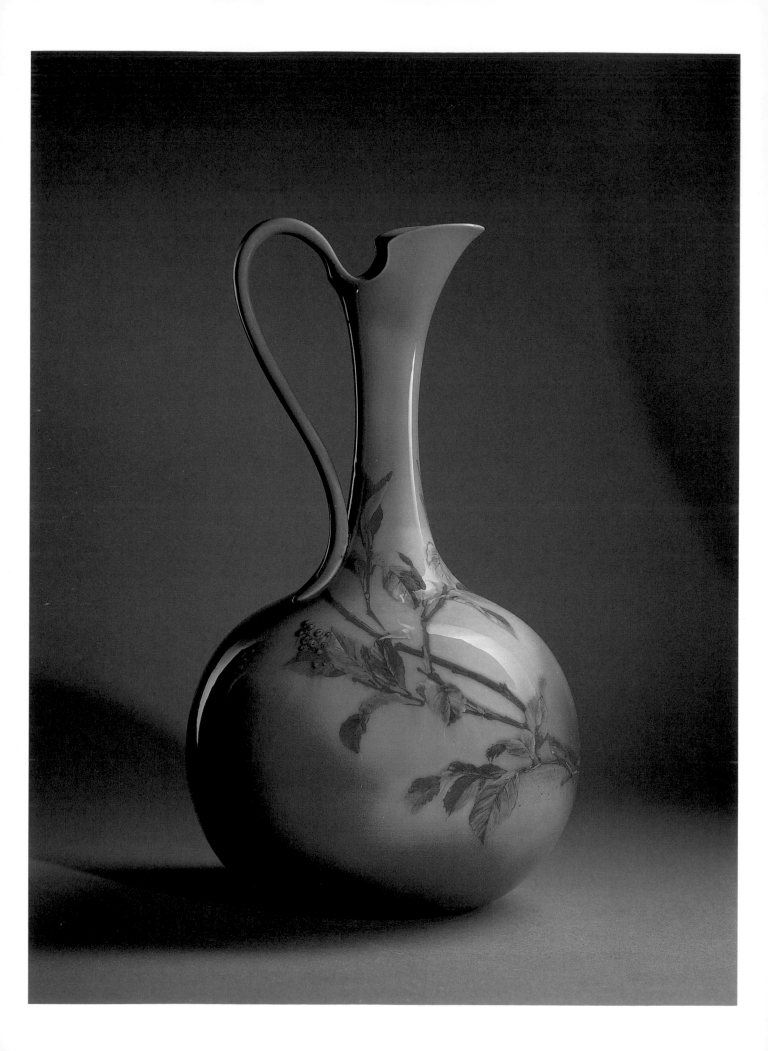

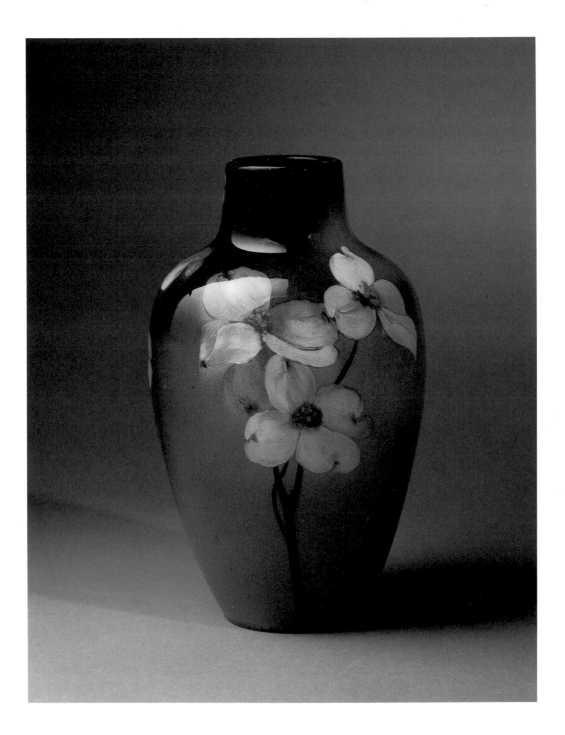

■

Pitcher, 1889

Matthew A. Daly (1860–1937), decorator
Rookwood Pottery, Cincinnati (1880–1967)
Glazed ginger clay, h. 13⅞ in.
Marks: Rookwood logo surmounted by three flames/1889/G
(impressed); M.A.D./L (incised)
PO-54-66

■

Vase, 1902

Sarah Alice Toohey (1872–1941), decorator
Rookwood Pottery, Cincinnati (1880–1967)
Glazed white clay, h. 9¾ in.
Marks: Rookwood logo surmounted by fourteen flames/II/905/C
(impressed); ST conjoined monogram (incised)
PO-29-70

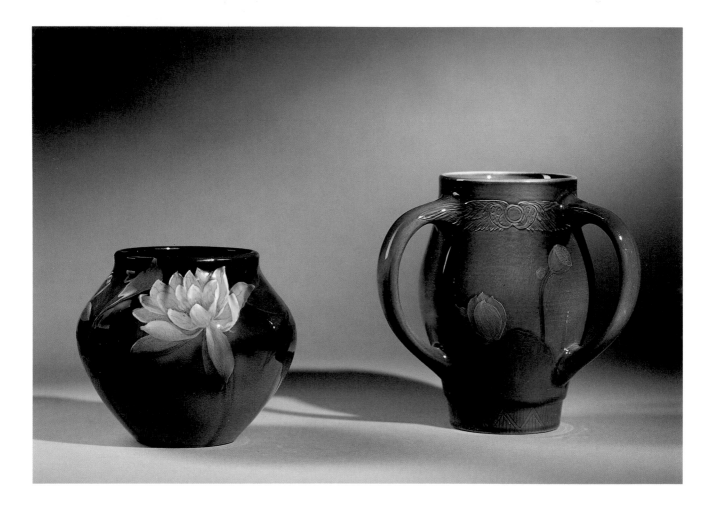

■

■

Vase, 1901

Mary Madeline Nourse (1870–1959), decorator
Rookwood Pottery, Cincinnati (1880–1967)
Glazed white clay, h. 6¼ in.
Marks: Rookwood logo surmounted by fourteen flames/906 C/I
(impressed); M.N. (incised)
Gift of Herbert O. and Susan C. Robinson PO-37-86

Vase, 1899

Mary Madeline Nourse (1870–1959), decorator
Rookwood Pottery, Cincinnati (1880–1967)
Glazed white clay, h. 8½ in.
Marks: Rookwood logo surmounted by thirteen flames/S1531
(impressed); M.N. (incised)
G

PO-53-66

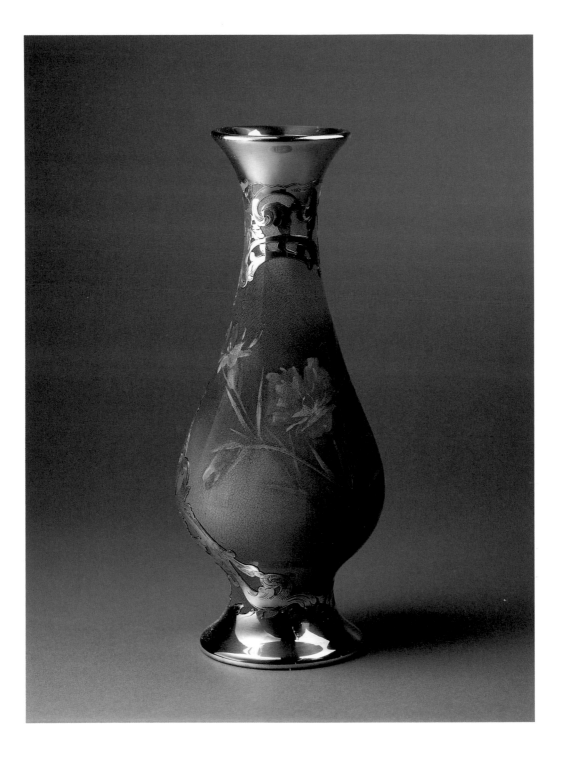

Vase, 1892

Sarah Alice Toohey (1872–1941), decorator
Rookwood Pottery, Cincinnati (1880–1967)
Glazed white clay with silver overlay, h. 10½ in.
Marks: Rookwood logo surmounted by six flames/640/W (impressed);
ST conjoined monogram (incised); 1892 (in pencil); in silver, Gorham
MFG. Co. (stamped); R 491 (engraved)
PO-10-67

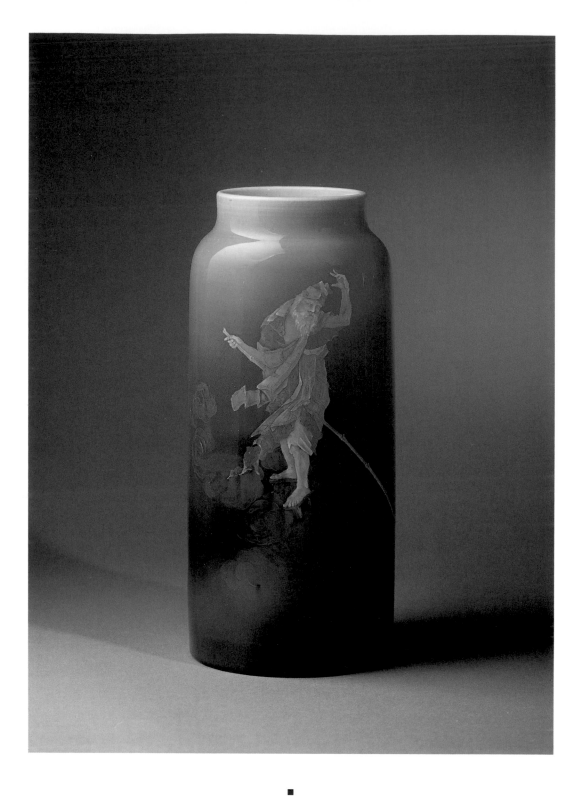

Vase, 1889

Matthew A. Daly (1860–1937), decorator
Rookwood Pottery, Cincinnati (1880–1967)
Glazed sage green clay, h. 13 in.
Marks: Rookwood logo surmounted by three flames/506/S (impressed);
MAD./L (incised)
PO-58-66

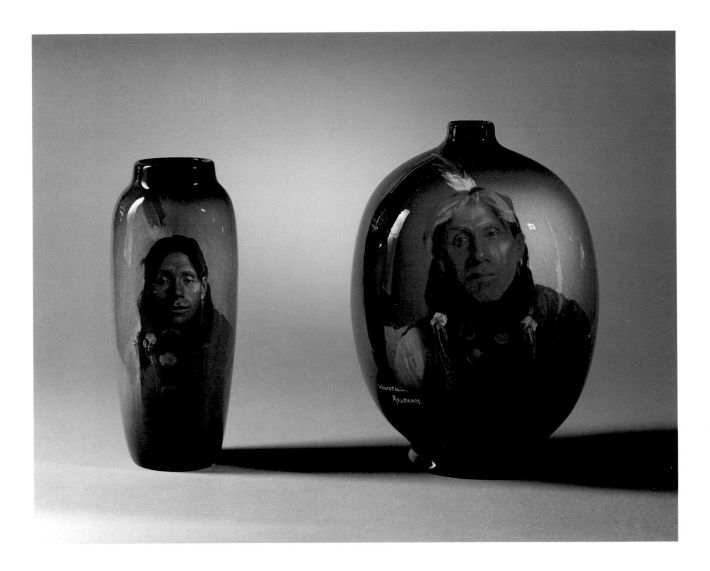

Vase, 1901

Grace Young (1869–1947), decorator
Rookwood Pottery, Cincinnati (1880–1967)
Glazed white clay, h. 10⅝ in.
Marks: Rookwood logo surmounted by fourteen flames/I/907/D
(impressed); GY conjoined monogram/Wanstall Arapahoe (incised)
Gift of Herbert O. and Susan C. Robinson PO-39-86

Vase, c. 1896–1907

A.F. Best, decorator
J.B. Owens Pottery, Zanesville, Ohio (1891–1907)
Glazed stoneware, h. 12¼ in.
Marks: J.B. Owens/Utopian/1085 (impressed); on side of vessel,
A.F. Best/Wanstall Arapahoe (glazed)
PO-7-65

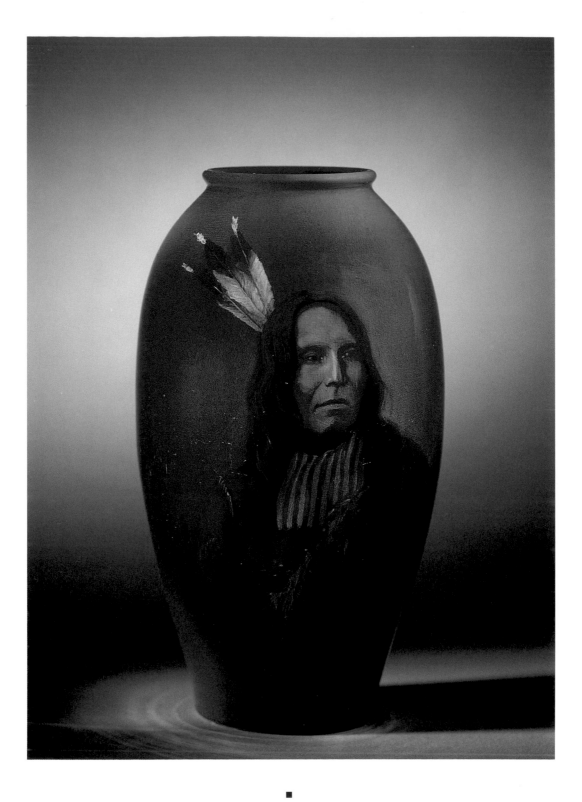

Vase, 1898

Matthew A. Daly (1860–1937)
Rookwood Pottery, Cincinnati (1880–1967)
Glazed white clay, h. 15¼ in.
Marks: Rookwood logo surmounted by twelve flames/857 (impressed);
MA Daly/Black Eye/Upper Yankton (incised)
Gift of Herbert O. and Susan C. Robinson PO-41-84

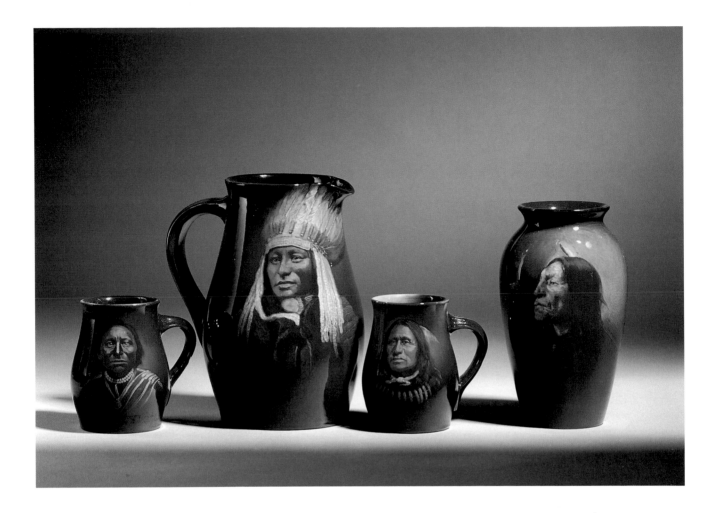

■

Ale Mug, 1897

Frederick Sturgis Laurence (active at Rookwood Pottery,
1895–1904), decorator
John Menzel and Pitts Harrison Burt, designers
Rookwood Pottery, Cincinnati (1880–1967)
Glazed white clay, h. 5¼ in.
Marks: Rookwood logo surmounted by eleven flames/837/∧
(impressed); Chief "Tam-Boo-Cha-Ket." Ute/SL (incised)
Gift of Herbert O. and Susan C. Robinson PO-32-86

■

Ale Mug, 1897

Frederick Sturgis Laurence (active at Rookwood Pottery,
1895–1904), decorator
John Menzel and Pitts Harrison Burt, designers
Rookwood Pottery, Cincinnati (1880–1967)
Glazed white clay, h. 5¼ in.
Marks: Rookwood logo surmounted by eleven flames/837/∧
(impressed); Standing Bear/Ponca/SL (incised)
Gift of Herbert O. and Susan C. Robinson PO-31-86

■

Ale Pitcher, 1897

Frederick Sturgis Laurence (active at Rookwood Pottery,
1895–1904), decorator
John Menzel and Pitts Harrison Burt, designers
Rookwood Pottery, Cincinnati (1880–1967)
Glazed white clay, h. 10 in.
Marks: Rookwood logo surmounted by eleven flames/837/∧
(impressed); Chief "Rain-in-the-face," Sioux./Sturgis Laurence/
Dec. 1897 (incised)
Gift of Herbert O. and Susan C. Robinson PO-30-86

■

Vase, 1901

Grace Young (1869–1947), decorator
Rookwood Pottery, Cincinnati (1880–1967)
Glazed white clay, h. 8¾ in.
Marks: Rookwood logo surmounted by fourteen flames/I/568 B
(impressed); Chief Wolf-Robe (Cheyenne) (incised)
Gift of Herbert O. and Susan C. Robinson PO-39-84

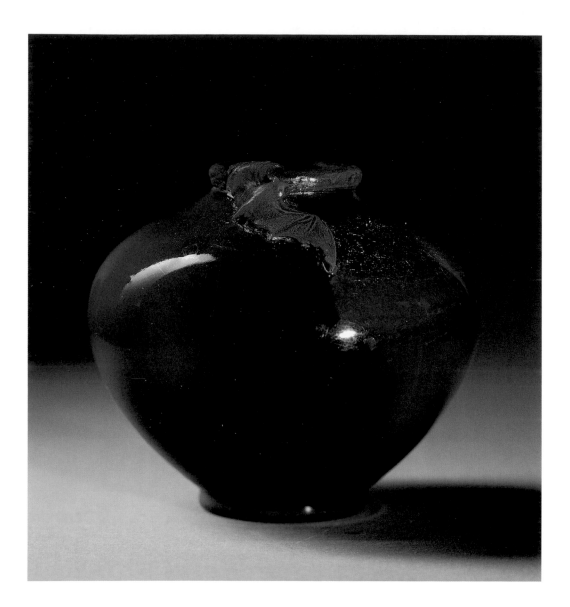

■

Vase, 1899

Kataro Shirayamadani (1865–1948), designer and decorator
Rookwood Pottery, Cincinnati (1880–1967)
Glazed red clay with applied electroformed copper, h. 5⅛ in.
Marks: Rookwood logo surmounted by thirteen flames/764 C
(impressed); Japanese characters for Kataro Shirayamadani (incised)
PO-73-87

■

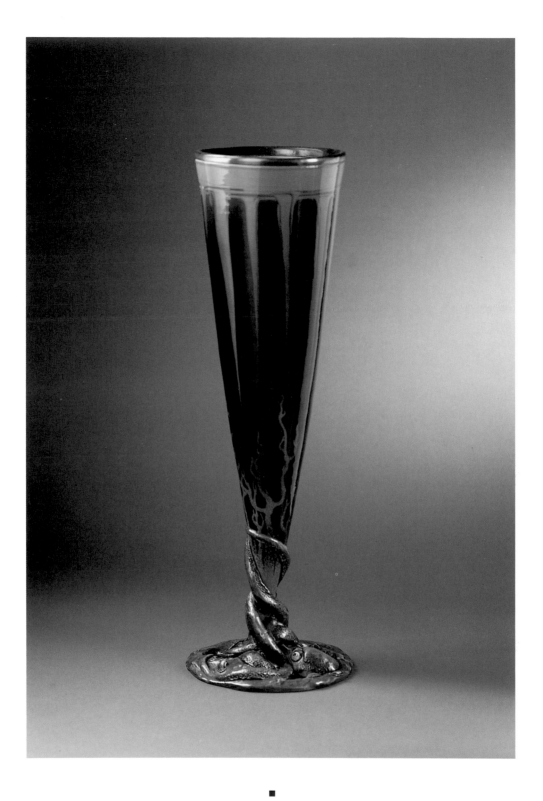

■

Vase, 1900

Kataro Shirayamadani (1865–1948), designer and decorator
Rookwood Pottery, Cincinnati (1880–1967)
Glazed white clay with metal mount, h. 18½ in.
Marks: Rookwood logo surmounted by fourteen flames/S 1537
(impressed); Japanese characters for Shirayamadani (incised)
PO-60-66

■

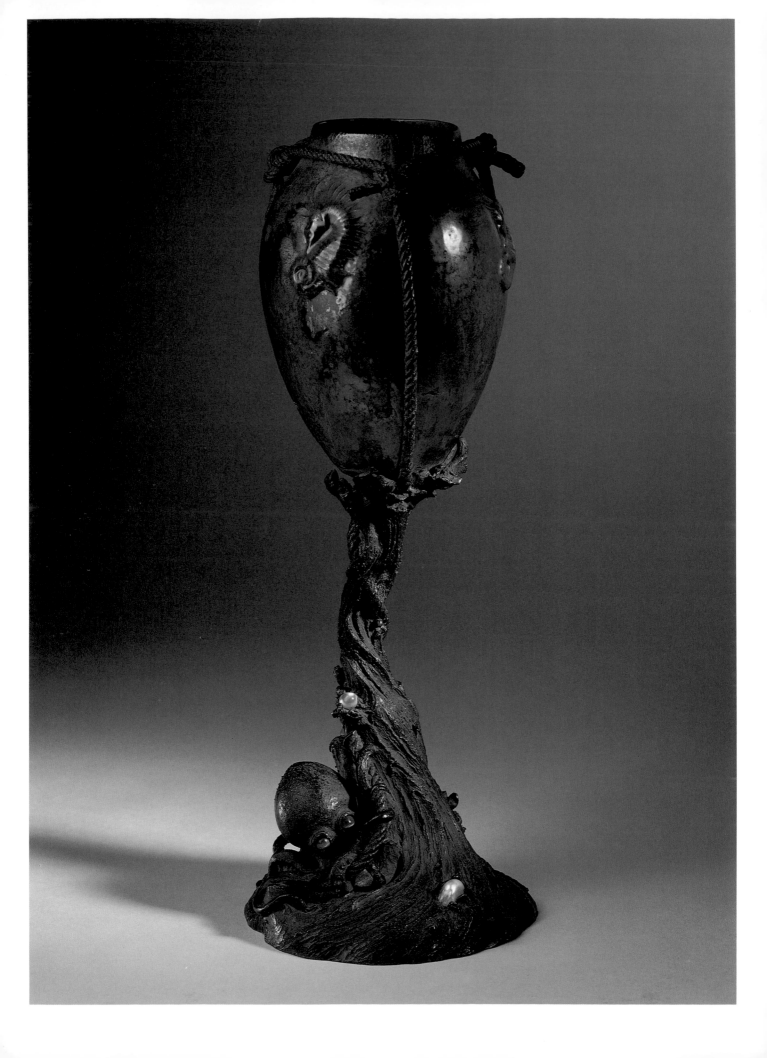

Vase, 1897

Maria Longworth Nichols Storer (1849–1932), designer
Rookwood Pottery, Cincinnati (1880–1967)
Glazed red clay with metal mounts, tiger's eyes,
moonstones, and pearl, h. 15⅝ in.
Marks: MLS/97 (glazed)
PO-52-66

Vase, 1932

Kataro Shirayamadani (1865–1948), decorator
Rookwood Pottery, Cincinnati (1880–1967)
Glazed white clay, h. 6⅞ in.
Marks: Rookwood logo surmounted by fourteen flames/XXXII/6308
(impressed); Japanese characters for Kataro Shirayamadani (incised)
PO-165-90

■

Vase, c. 1902

S.A. Weller Pottery, Zanesville, Ohio (1872–1949)
Glazed white clay, h. 12¾ in.
Marks: 301/1[?] (impressed); Dickens/Weller (incised); on side,
Mr. Pecksniff (glazed in relief)
PO-28-66

■

Vase, after 1897

S.A. Weller Pottery, Zanesville, Ohio (1872–1949)
Glazed red clay, h. 11½ in.
Marks: Dickensware/Weller, Dickensware/Weller/607 (impressed)
PO-44-69

Vase, c. 1895–1905

Frank Ferrell (active at S.A. Weller Pottery, c. 1895–1905), decorator
S.A. Weller Pottery, Zanesville, Ohio (1872–1949)
Glazed yellow clay, h. 11½ in.
Marks: Louwelsa/2/Weller/X/31/O (impressed); Ferrell (glazed)
Gift of Herbert O. and Susan C. Robinson PO-116-86

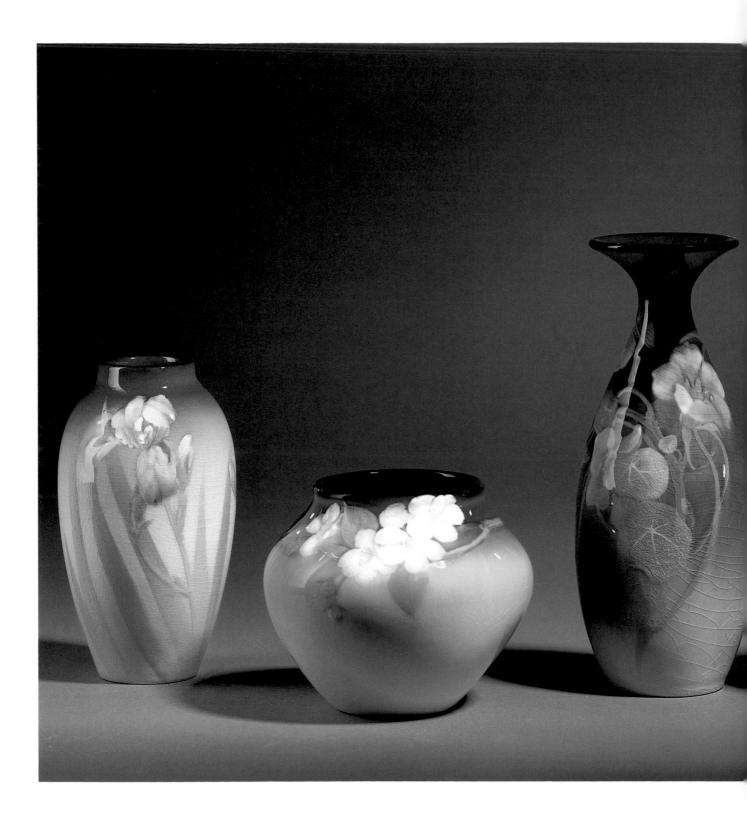

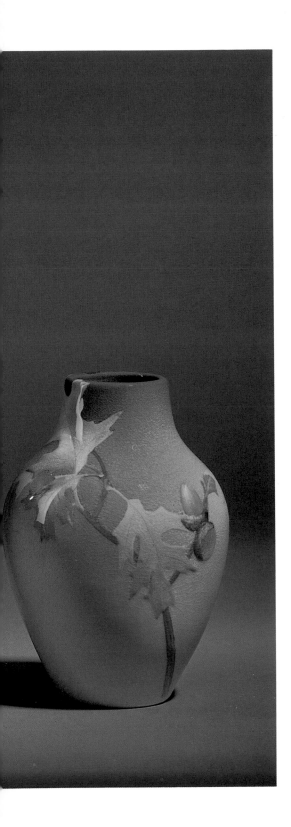

■

Vase, 1911

Caroline Francis Steinle (1871–1944), decorator
Rookwood Pottery, Cincinnati (1880–1967)
Glazed white clay, h. 7 in.
Marks: Rookwood logo surmounted by fourteen flames/XI/900 D
(impressed); CS conjoined monogram (incised)
PO-86-68

■

Vase, 1909

Elizabeth Neave Lincoln (Lingenfelter) (1876–1957), decorator
Rookwood Pottery, Cincinnati (1880–1967)
Glazed white clay, h. 4⅞ in.
Marks: Rookwood logo surmounted by fourteen flames/IX/906
(impressed); LNL/W (incised)
PO-8-66

■

Vase, 1902

Sara Sax (1870–1949), decorator
Pitts Harrison Burt, designer
Rookwood Pottery, Cincinnati (1880–1967)
Glazed white clay, h. 9¾ in.
Marks: Rookwood logo surmounted by fourteen flames/II/482
(impressed); SAX conjoined monogram (incised)
PO-17-66

■

Vase, 1902

Josephine Ella Zettel (1874–1954)
Rookwood Pottery, Cincinnati (1880–1967)
Glaze white clay, h. 7½ in.
Marks: Rookwood logo surmounted by fourteen flames/II/933 D
(impressed); JEZ conjoined monogram/W (incised)
PO-20-69

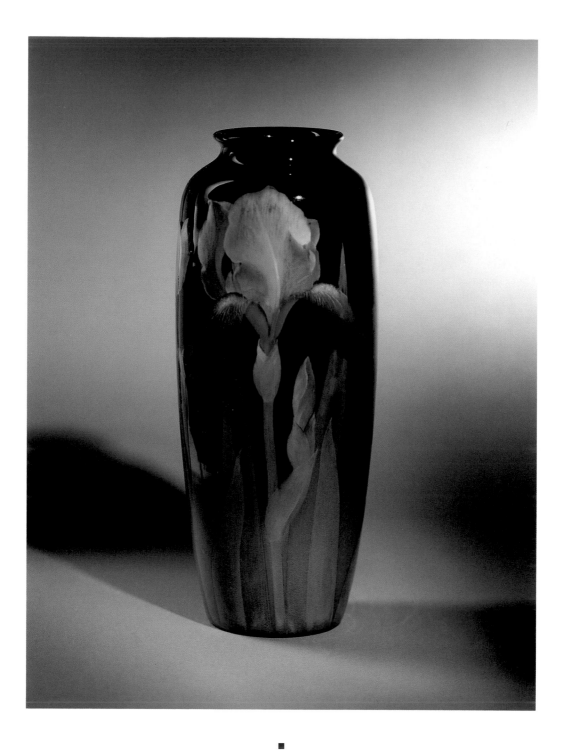

Vase, 1903

Charles (Carl) Schmidt (1875–1959), decorator
Rookwood Pottery, Cincinnati (1880–1967)
Glazed white clay, h. 13½ in.
Marks: Rookwood logo surmounted by fourteen flames/III/904 B
(impressed); W/CS conjoined monogram (incised)
PO-5-92

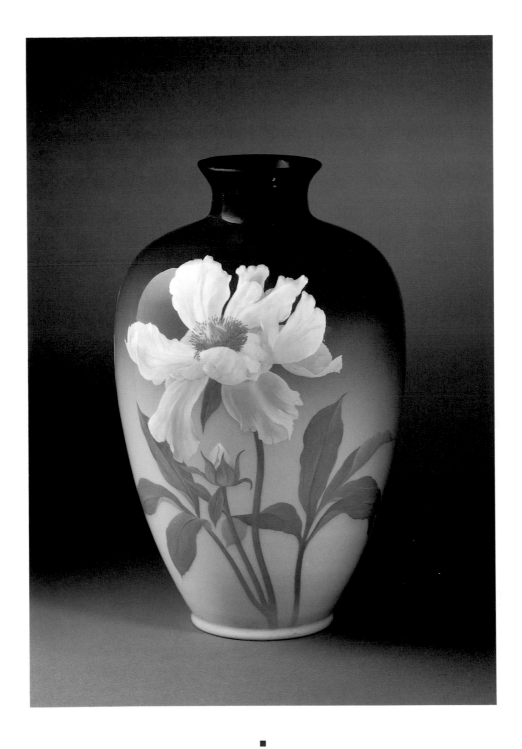

■

Vase, 1907

Charles (Carl) Schmidt (1875–1959), decorator
Rookwood Pottery, Cincinnati (1880–1967)
Glazed white clay, h. 14⅝ in.
Marks: Rookwood logo surmounted by fourteen flames/VII/787 B
(impressed); W and CS conjoined monogram (incised)
PO-57-66

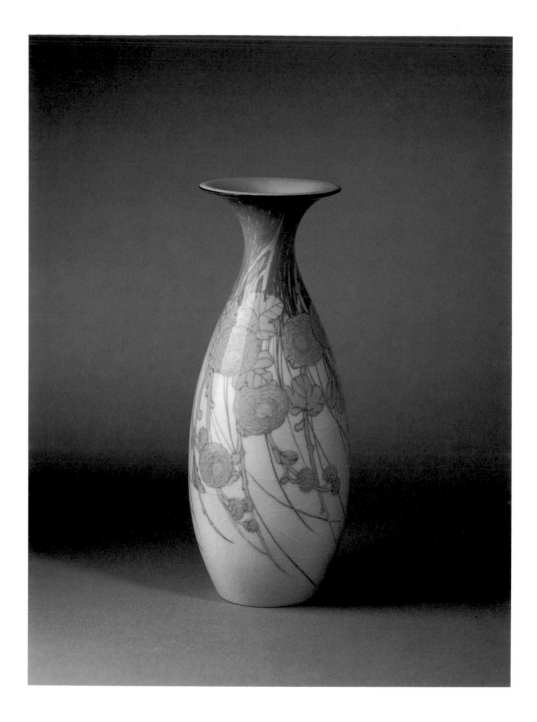

Vase, 1920

Sara Sax (1870–1949), decorator
Pitts Harrison Burt, designer
Rookwood Pottery, Cincinnati (1880–1967)
Glazed white clay, h. 10 in.
Marks: Rookwood logo surmounted by fourteen flames/XX/482
(impressed); SAX conjoined monogram (incised)
PO-21-69

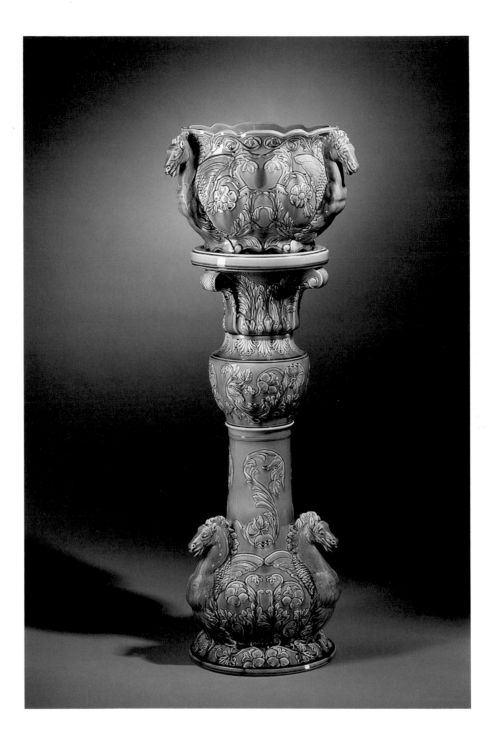

■

Jardiniere and Pedestal, c. 1903

A. Radford Pottery, Zanesville, Ohio (1903–12)
Glazed white clay, h. 41½ in.
Unmarked
Gift of Herbert O. and Susan C. Robinson PO-79-93A, B

·

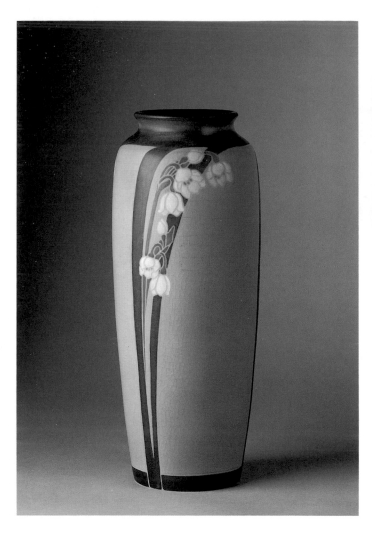

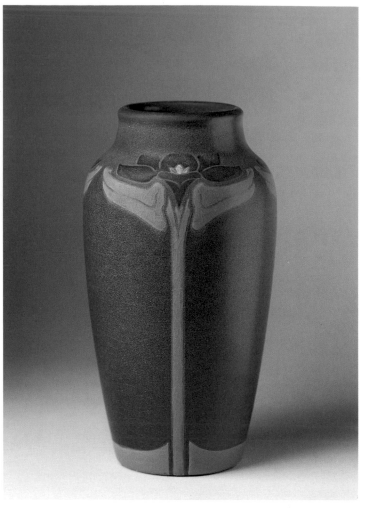

■

Vase, 1915

Sara Sax (1870–1949), decorator
Rookwood Pottery, Cincinnati (1880–1967)
Glazed white clay, h. 11⅛ in.
Marks: Rookwood logo surmounted by fourteen flames/XV/904 CC/V
(impressed); V./SAX conjoined monogram (incised)
PO-16-66

■

Vase, 1910

Lorinda Epply (1874–1951), decorator
Rookwood Pottery, Cincinnati (1880–1967)
Glazed white clay, h. 8⅜ in.
Marks: Rookwood logo surmounted by fourteen flames/X/943 D/V
(impressed); LE conjoined monogram (incised)
PO-17-67

■

Vase, 1911

Sara Sax (1870–1949), decorator
Kataro Shirayamadani (1865–1948), designer
Rookwood Pottery, Cincinnati (1880–1967)
Glazed white clay, h. 7½ in.
Marks: Rookwood logo surmounted by fourteen flames/XI/589 F/V
(impressed); SAX conjoined monogram/GV./1 (incised)
PO-13-66

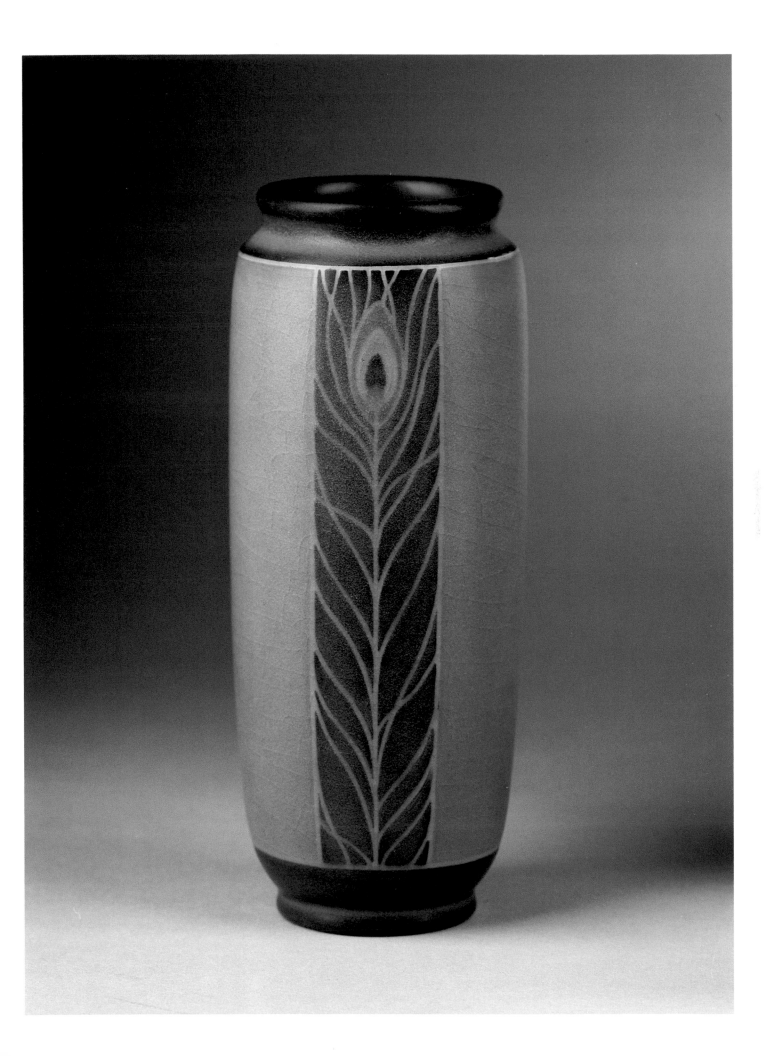

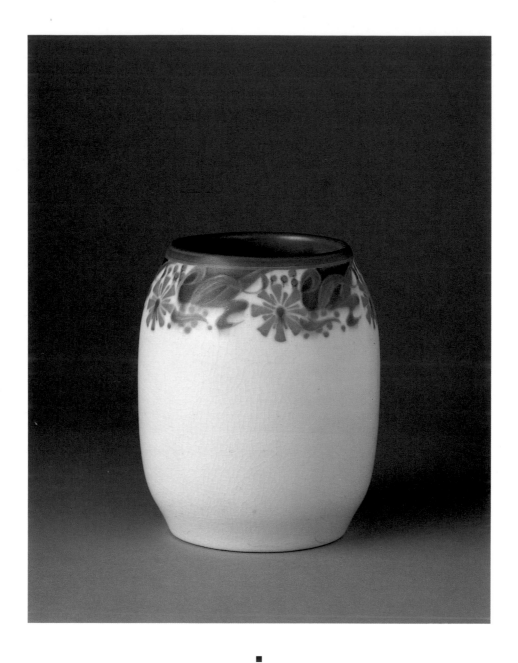

■

Vase, 1915

Mary Grace Denzler (b. 1892), decorator
Rookwood Pottery, Cincinnati (1880–1967)
Glazed white clay, h. 5¾ in.
Marks: Rookwood logo surmounted by fourteen flames/XV/2117/V/
MGD monogram (impressed); X (engraved)
PO-37-76

■

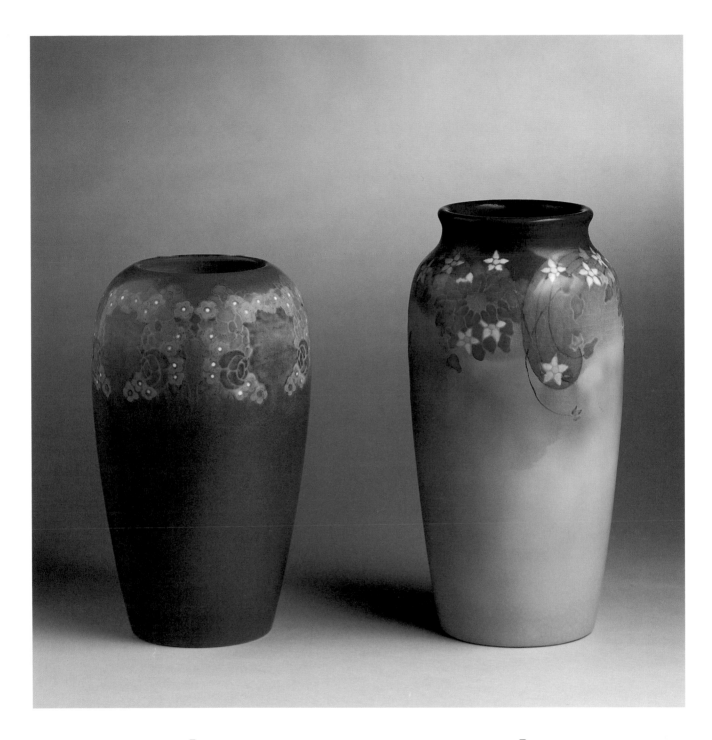

■

Vase, 1916

Katherine Van Horne (d. 1918), decorator
Rookwood Pottery, Cincinnati (1880–1967)
Glazed white clay, h. 9½ in.
Marks: Rookwood logo surmounted by fourteen flames; .XVI/1126 C/V
(impressed); KVH conjoined monogram/D/XIII (incised)
PO-37-68

■

Vase, 1919

Margaret Helen McDonald (1893–1964), decorator
Rookwood Pottery, Cincinnati (1880–1967)
Glazed white clay, h. 11 in.
Marks: Rookwood logo surmounted by fourteen flames/.XIX/1065 B/V
(impressed); MHM conjoined monogram (incised)
Gift of Herbert O. and Susan C. Robinson PO-58-86

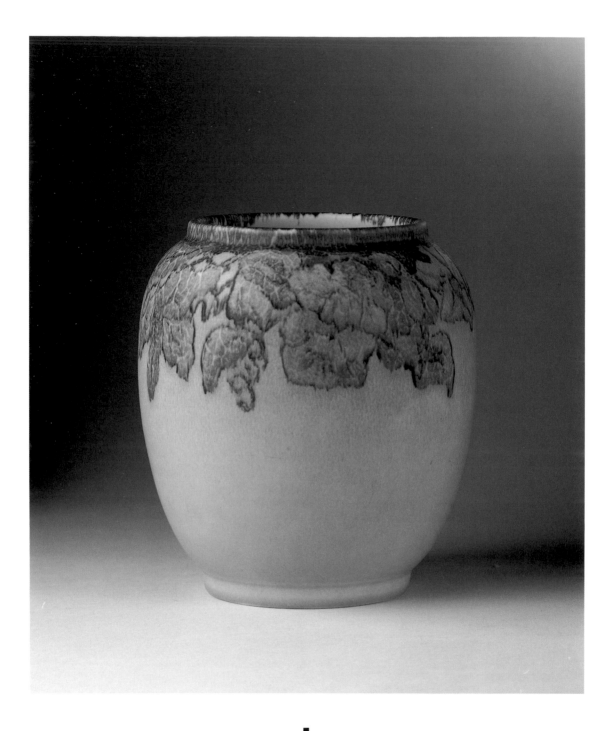

■

Vase, 1924

Catherine Pissoreff Covalenco (1896–1932), decorator
John Hamilton Delaney Wareham (1871–1954), designer
Rookwood Pottery, Cincinnati (1880–1967)
Glazed white clay, h. 8 in.
Marks: Rookwood logo surmounted by fourteen flames/XXIV/.2245
(impressed); CC (glazed)
Gift of Herbert O. and Susan C. Robinson PO-253-89

■

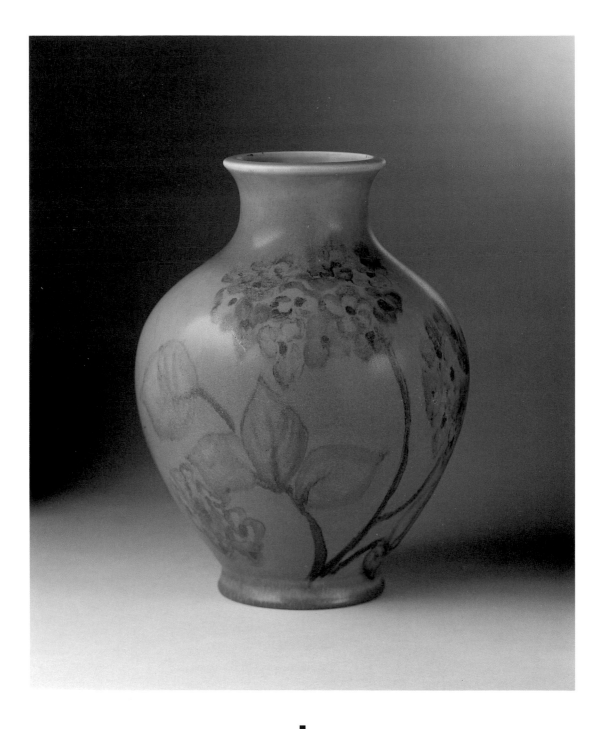

■

Vase, 1928

Delia Workum (1904–1966), decorator
John Hamilton Delaney Wareham (1871–1954), designer
Rookwood Pottery, Cincinnati (1880–1967)
Glazed white clay, h. 11½ in.
Marks: Rookwood logo surmounted by fourteen flames/XXVIII/2 9918-B
(impressed); DW conjoined monogram (under glaze)
PO-65-67

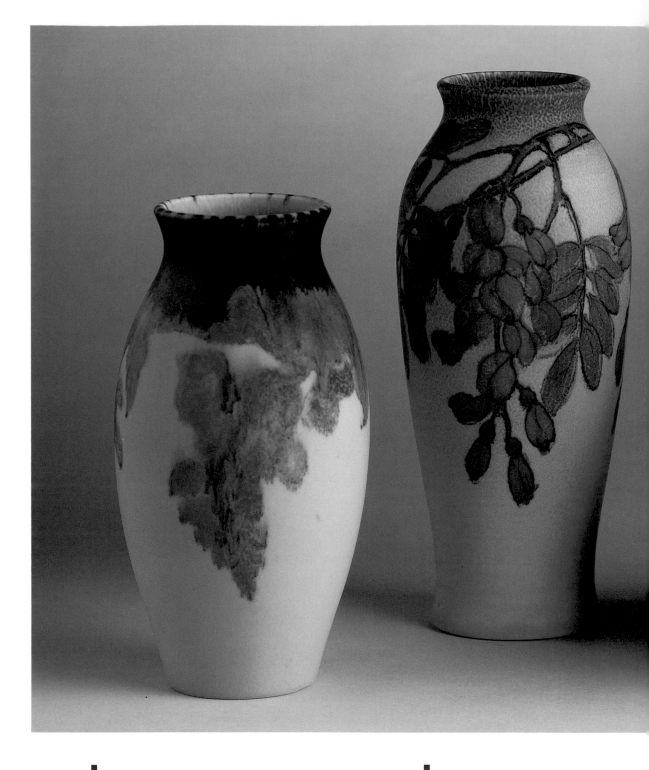

■

Vase, 1929

Elizabeth Neave Lincoln (Lingenfelter) (1876–1957), decorator
William Watts Taylor (1847–1913), designer
Rookwood Pottery, Cincinnati (1880–1967)
Glazed white clay, h. 8 in.
Marks: Rookwood logo surmounted by fourteen flames/XXIX/.356 D
(impressed); LNL (in glaze)
Gift of Herbert O. and Susan C. Robinson PO-60-86

■

Vase, 1927

Margaret Helen McDonald (1893–1964), decorator
Rookwood Pottery, Cincinnati (1880–1967)
Glazed white clay, h. 9⅞ in.
Marks: Rookwood logo surmounted by fourteen flames/XXVII/937;
MHM (glazed)
Gift of Herbert O. and Susan C. Robinson PO-32-90

■

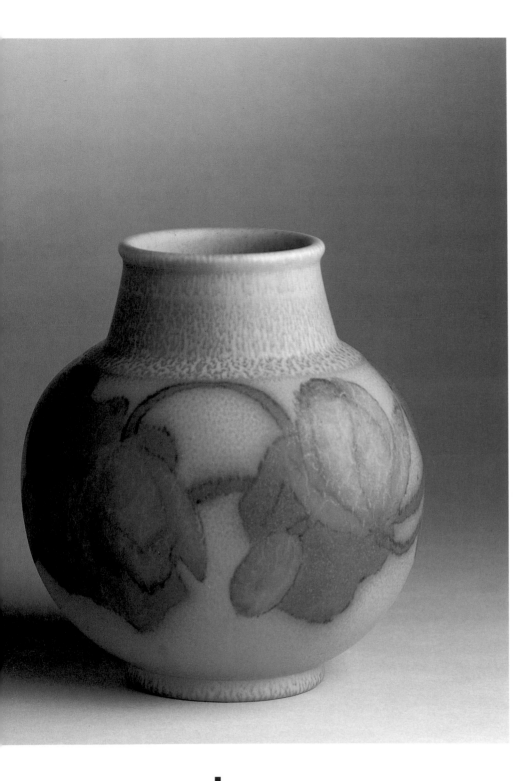

■

Vase, 1929

Jens Jacob Herring Krog Jensen (d. 1978), decorator
John Hamilton Delaney Wareham (1871–1954), designer
Rookwood Pottery, Cincinnati (1880–1967)
Glazed white clay, h. 7¾ in.
Marks: Rookwood logo surmounted by fourteen flames/XXIX/2969
(impressed); JHK (glazed)
Gift of Herbert O. and Susan C. Robinson PO-14-82

.

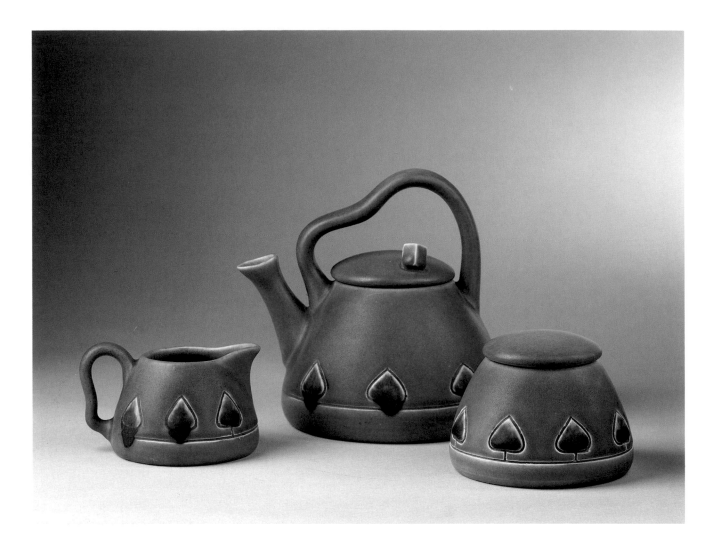

■

Tea Set, 1910

William E. Hentschel (1892–1962), decorator
Rookwood Pottery, Cincinnati (1880–1967)
Glazed white clay: teapot, h. 6⅝ in.; creamer, h. 2⅝ in.;
sugar bowl, h. 3¼ in.
Marks: Rookwood logo surmounted by fourteen flames/X/770/V
(impressed); WEH conjoined monogram (incised)
PO-8-69A, B, C

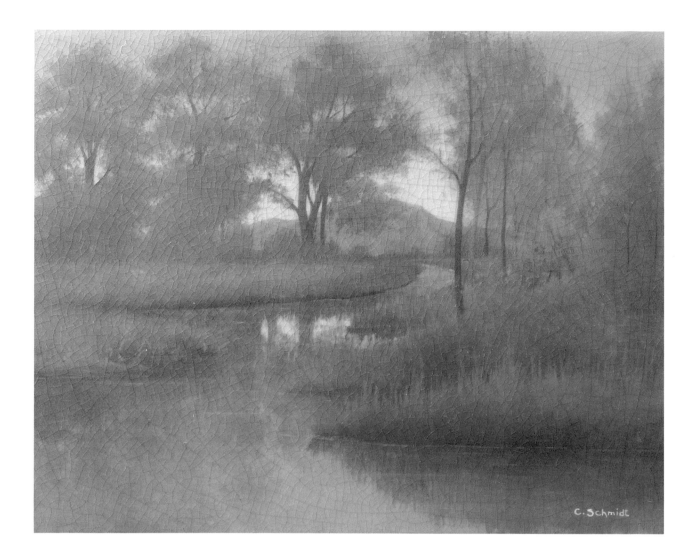

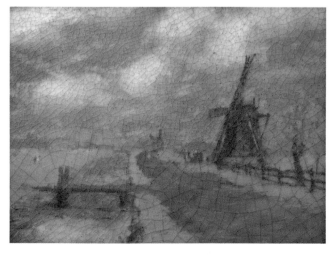

■

Plaque, 1916

Charles (Carl) Schmidt (1875–1959), decorator
Rookwood Pottery, Cincinnati (1880–1967)
Glazed white clay, 8⅝ x 11 in.
Marks: Rookwood logo surmounted by fourteen flames/XVI/V
(impressed); on front lower right, C. Schmidt (glazed)
PO-5-68

■

Plaque, 1914

Edward Timothy Hurley (1869–1950), decorator
Rookwood Pottery, Cincinnati (1880–1967)
Glazed white clay, 5¾ x 7⅝ in.
Marks: Rookwood logo surmounted by fourteen flames/XIV/V
(impressed); . . . (incised); front lower left, ETH (incised)
PO-5-65

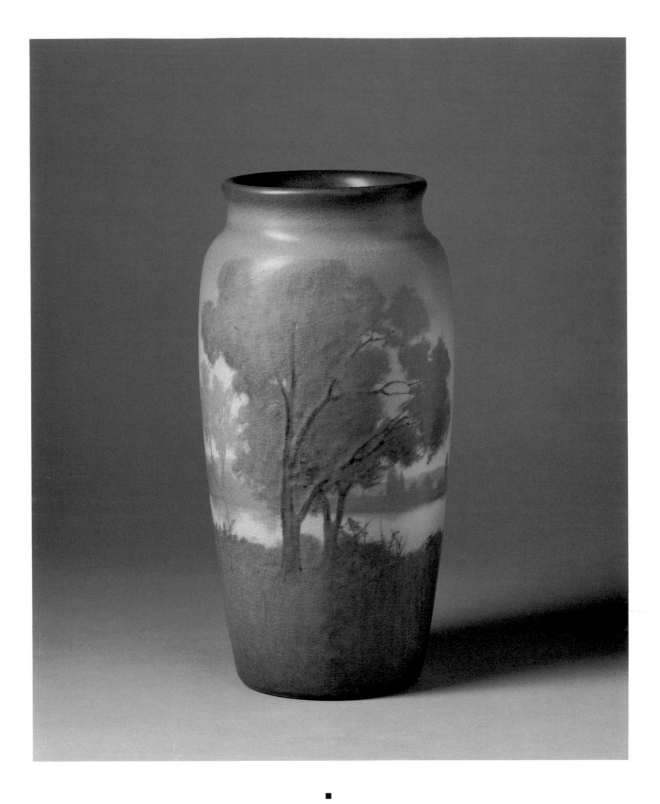

Vase, 1913

Sara Sax (1870–1949), decorator
Rookwood Pottery, Cincinnati (1880–1967)
Glazed white clay, h. 10¾ in.
Marks: Rookwood logo surmounted by fourteen flames/XIII/1065 B/V
(impressed); SAX conjoined monogram (incised)
Gift of Herbert O. and Susan C. Robinson PO-33-82

■

Plaque, 1913

Lenore Asbury (1866–1933), decorator
Rookwood Pottery, Cincinnati (1880–1967)
Glazed white clay, 9¼ x 14⅝ in.
Marks: Rookwood logo surmounted by fourteen flames/XIII/V
(impressed); . . . (incised); on front lower left, L.A. (glazed)
PO-1-79

■

Plaque, 1927

Frederick Daniel Henry Rothenbusch, decorator
Rookwood Pottery, Cincinnati (1880–1967)
Glazed white clay, 9⅜ x 14½ in.
Marks: Rookwood logo surmounted by fourteen flames/XXVII/.
(impressed); on front lower right, FR conjoined monogram (glazed)
PO-35-82

■

Plaque, 1927

Edward George Diers (1870–1947), decorator
Rookwood Pottery, Cincinnati (1880–1967)
Glazed white clay, 8 x 4 in.
Marks: Rookwood logo surmounted by fourteen flames/XXVII
(impressed)/paper label: "Birches and the ___ /E. Diers"
Gift of Herbert O. and Susan C. Robinson PO-73-86

.

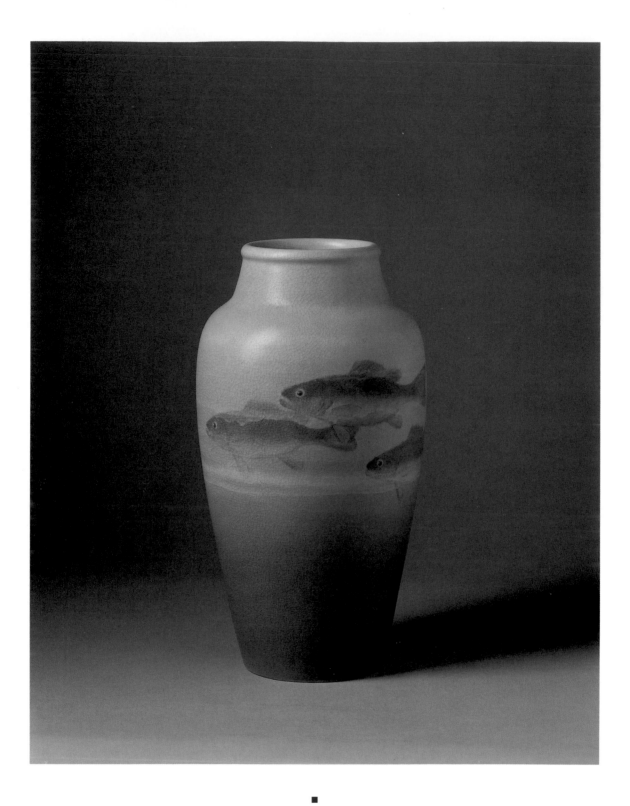

■

Vase, 1904

Kataro Shirayamadani (1865–1948), decorator
Rookwood Pottery, Cincinnati (1880–1967)
Glazed white clay, h. 12¼ in.
Marks: Rookwood logo surmounted by fourteen flames/IV/II BZ V
(impressed); Japanese characters for Kataro Shirayamadani (incised)
PO-55-68

·

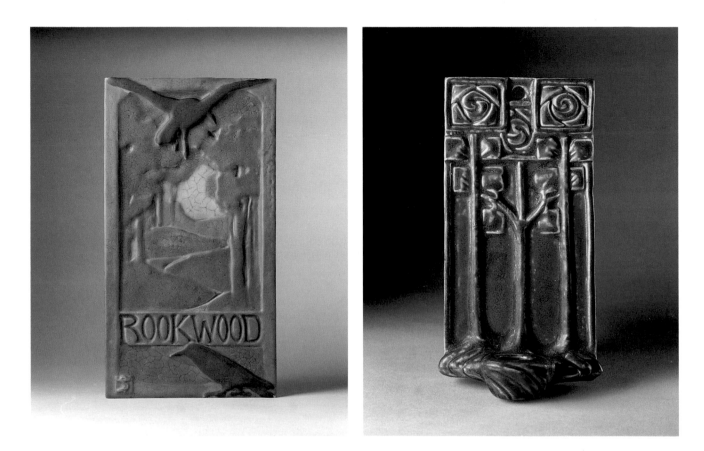

■

Plaque, 1910

Sarah Alice Toohey (1872–1941), decorator
Rookwood Pottery, Cincinnati (1880–1967)
Glazed faience, h. 14 ⅝ in.
Marks: Rookwood/Faience/1356 Y/O [?] (impressed);
on front lower left, ST conjoined monogram (in relief)
PO-14-69

■

Candleholder, 1922

Rookwood Pottery, Cincinnati (1880–1967)
Glazed white clay, h. 8 ⅝ in.
Marks: Rookwood logo surmounted by fourteen flames/XXII/1760
(impressed)
PO-31-69

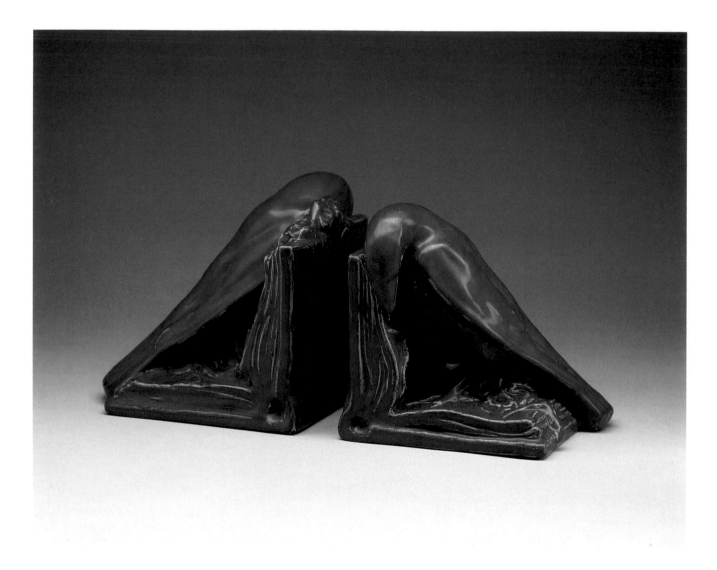

■

Bookends, 1918

William Purcell McDonald (1865–1931), designer
Rookwood Pottery, Cincinnati (1880–1967)
Glazed porcelain, h. 6 in.
Marks: Rookwood logo surmounted by fourteen flames/XVIII/2274/P/
WMCD (impressed)
PO-18-74A, B

■

Centerpiece, 1925

William Purcell McDonald (1865–1931), designer
Rookwood Pottery, Cincinnati (1880–1967)
Glazed white clay, h. 11 ⅝ in.
Marks: Rookwood logo surmounted by fourteen flames/XXV/2512
(impressed)
PO-51-71

■

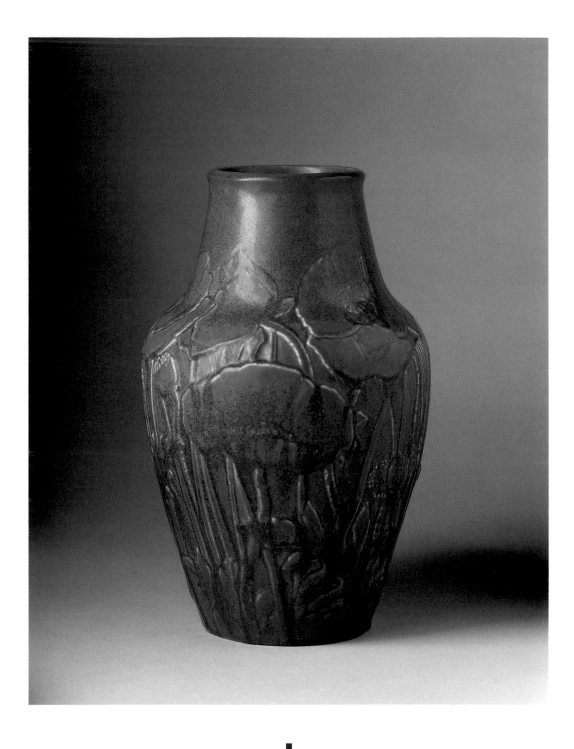

■

Vase, 1928

Kataro Shirayamadani (1865–1948), designer
Rookwood Pottery, Cincinnati (1880–1967)
Glazed white clay, h. 11¾ in.
Marks: Rookwood logo surmounted by fourteen flames/XXVIII/6006
(impressed)
PO-45-69

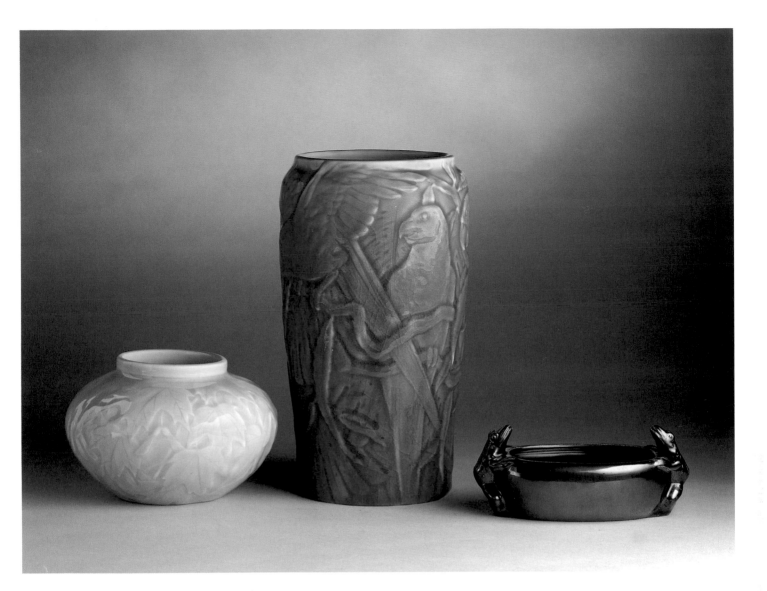

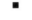

Vase, 1923

Kataro Shirayamadani (1865–1948), designer
Rookwood Pottery, Cincinnati (1880–1967)
Glazed white clay, h. 4½ in.
Marks: Rookwood logo surmounted by
fourteen flames/XXIII/2693 (impressed)
Gift of Herbert O. and Susan C. Robinson PO-38-90

Vase, 1928

Kataro Shirayamadani (1865–1948), designer
Rookwood Pottery, Cincinnati (1880–1967)
Glazed white clay, h. 10⅞ in.
Marks: Rookwood logo surmounted by
fourteen flames/XXVIII/6088/. (impressed)
Gift of Herbert O. and Susan C. Robinson PO-13-79

Dish, 1934

Kataro Shirayamadani (1865–1948), designer
Rookwood Pottery, Cincinnati (1880–1967)
Glazed white clay, h. 2⅞ in.
Marks: Rookwood logo surmounted by
fourteen flames/XXXIV/6282 (impressed)
Gift of Herbert O. and Susan C. Robinson PO-12-76

■

Vase, 1929

William E. Hentschel (1892–1962), decorator
Rookwood Pottery, Cincinnati (1880–1967)
Glazed white clay, h. 9¼ in.
Marks: Rookwood logo surmounted by fourteen flames/XXIX/927 D
(impressed); WEH conjoined monogram (incised)
PO-51-85

■

Vase, 1929

William E. Hentschel (1892–1962), decorator
John Hamilton Delaney Wareham (1871–1954), designer
Rookwood Pottery, Cincinnati (1880–1967)
Glazed white clay, h. 6¾ in.
Marks: Rookwood logo surmounted by fourteen flames/XXIX/.6013
(impressed); WEH conjoined monogram (incised)
PO-7-69

■

Bowl, 1928

William E. Hentschel (1892–1962), decorator
John Hamilton Delaney Wareham (1871–1954), designer
Rookwood Pottery, Cincinnati (1880–1967)
Glazed white clay, h. 5½ in.
Marks: Rookwood logo surmounted by fourteen flames/XXVIII/2254 D
(impressed); WEH conjoined monogram (incised)
PO-23-71

■

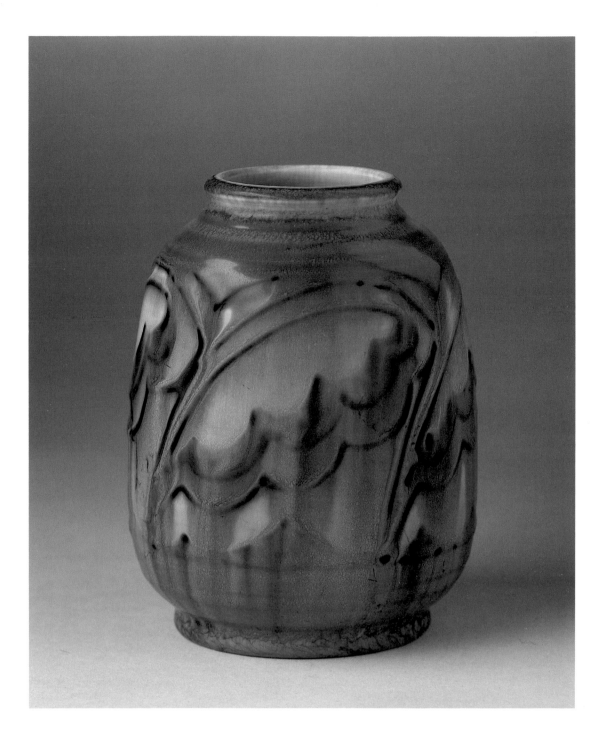

■

Vase, 1930

Elizabeth Barrett, decorator
John Hamilton Delaney Wareham (1871–1954), designer
Rookwood Pottery, Cincinnati (1880–1967)
Glazed white clay, h. 6⅛ in.
Marks: Rookwood logo surmounted by fourteen flames/XXX/.6196 E
(impressed); EB conjoined monogram (incised);
50th anniversary logo (glazed)
Gift of Herbert O. and Susan C. Robinson PO-3-87

•

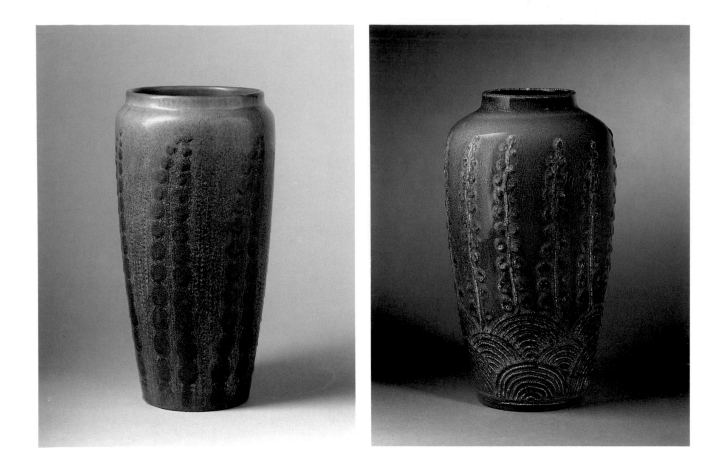

■

Vase, 1927

William E. Hentschel (1892–1962), decorator
Rookwood Pottery, Cincinnati (1880–1967)
Glazed white clay, h. 15 in.
Marks: Rookwood logo surmounted by fourteen flames/XXVII/1369 B
(impressed); WEH (incised)
PO-18-68

Vase, 1963

Margaret Helen McDonald (1893–1964), decorator
John Hamilton Delaney Wareham (1871–1954), designer
Rookwood Pottery, Cincinnati and Starkville, Mississippi (1880–1967)
White earthenware, h. 12¼ in.
Marks: Rookwood logo surmounted by fourteen flames/LXIII/6777/R/
Rookwood Pottery/Starkville/Miss. (impressed)
PO-116-80

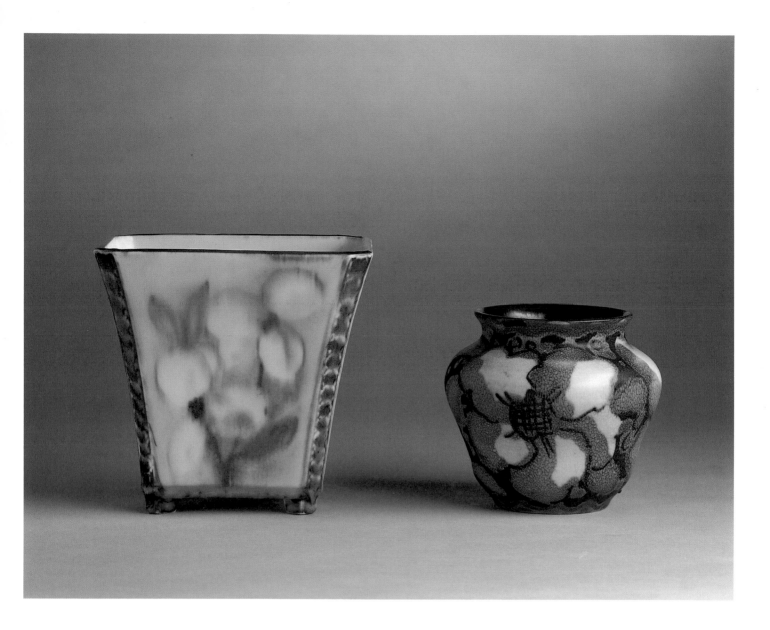

■

Vase, 1943

Jens Jacob Herring Krog Jensen (d. 1978), decorator
Kataro Shirayamadani (1865–1948), designer
Rookwood Pottery, Cincinnati (1880–1967)
Glazed white clay, h. 6¼ in.
Marks: Rookwood logo surmounted by fourteen flames/XLIII/6036
(impressed); conjoined monogram JJHKJ (glazed)
Gift of Herbert O. and Susan C. Robinson PO-93-86

■

Vase, 1933

Jens Jacob Herring Krog Jensen (d. 1978), decorator
Rookwood Pottery, Cincinnati (1880–1967)
Glazed sage clay, h. 4½ in.
Marks: Rookwood logo surmounted by fourteen flames/XXXIII/S
(impressed); JHK (glazed)
PO-4-66

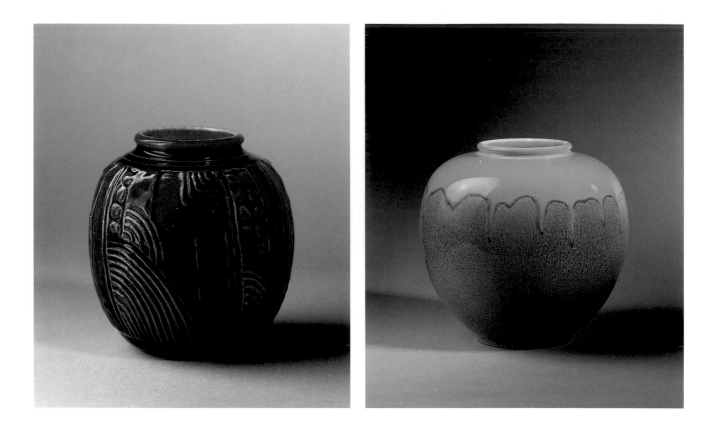

■

Vase, 1931

Wilhemine Rehm (1899–1967), designer
Rookwood Pottery, Cincinnati (1880–1967)
Glazed white clay, h. 4⅝ in.
Marks: Rookwood logo surmounted by fourteen flames/XXXI/6232
(impressed); and original paper label
Gift of Herbert O. and Susan C. Robinson PO-32-82

■

Vase, 1951

John Hamilton Delaney Wareham (1871–1954), decorator
Rookwood Pottery, Cincinnati (1880–1967)
Glazed white clay, h. 7¼ in.
Marks: Rookwood logo surmounted by fourteen flames/LI/6204 C
(impressed)
Gift of Herbert O. and Susan C. Robinson PO-100-86

■

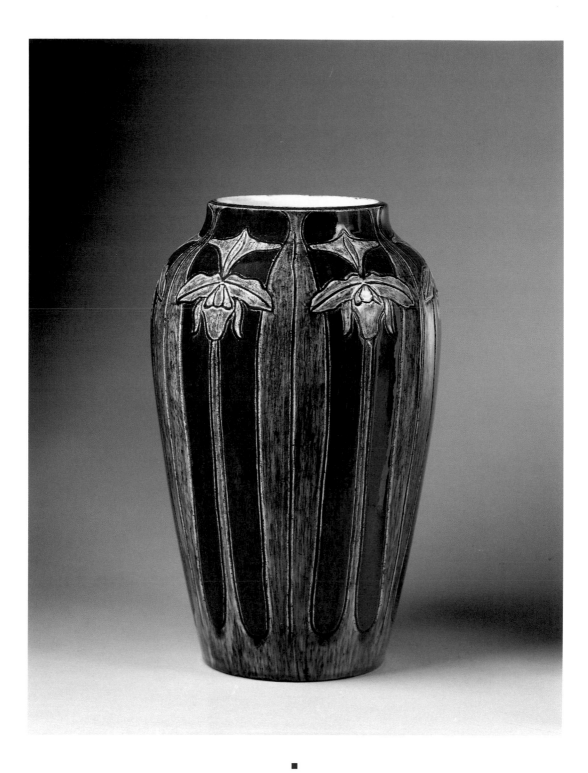

Vase, 1902

Marie Medora Ross (active at Newcomb, 1896–1906), decorator
Joseph Fortune Meyer (1848–1954), potter
Newcomb Pottery, New Orleans (1895–1940)
Glazed white clay, h. 11¾ in.
Marks: Newcomb College (NC) conjoined monogram (impressed
and glazed in blue); MR conjoined monogram/U/JM conjoined
monogram (incised); Q9 (glazed in blue)
PO-93-81

Vase, 1905

Newcomb Pottery, New Orleans (1895–1940)
Glazed white clay, h. 6⅝ in.
Marks: Newcomb College (NC) conjoined monogram/ W (impressed);
AK 88 (glazed); L.H. (incised and glazed)
PO-48-67

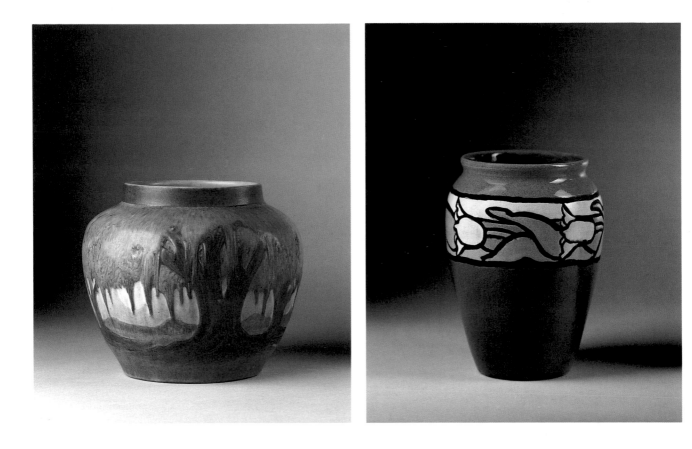

■

Vase, 1928

Jonathan Browne Hunt (1876–1943), potter
Newcomb Pottery, New Orleans (1895–1940)
Glazed white clay, h. 6¼ in.
Marks: Newcomb College (NC) conjoined monogram/RB 86/61
(impressed); JH conjoined monogram/FS (incised)
PO-80-80

■

Vase, c. 1906–08

Saturday Evening Girls (1906–08)
of Paul Revere Pottery,
Boston and Brighton, Massachusetts (1908–42)
Glazed tan clay, h. 6⅝ in.
Marks: SEG/LMD/11-20 (glazed)
PO-88-88

Vase, c. 1897–1907

Grueby Pottery, Boston (1897–1913)
Glazed stoneware, h. 24½ in.
Marks: Grueby Faience Co./Boston/USA (impressed)
PO-78-68

■

Vase, c. 1897–1907

Grueby Pottery, Boston (1897–1913)
Glazed stoneware, h. 11 in.
Marks: Boston, U.S.A. (impressed); I (incised); original paper label of
Grueby Faience and Tile Company
PO-72-66

■

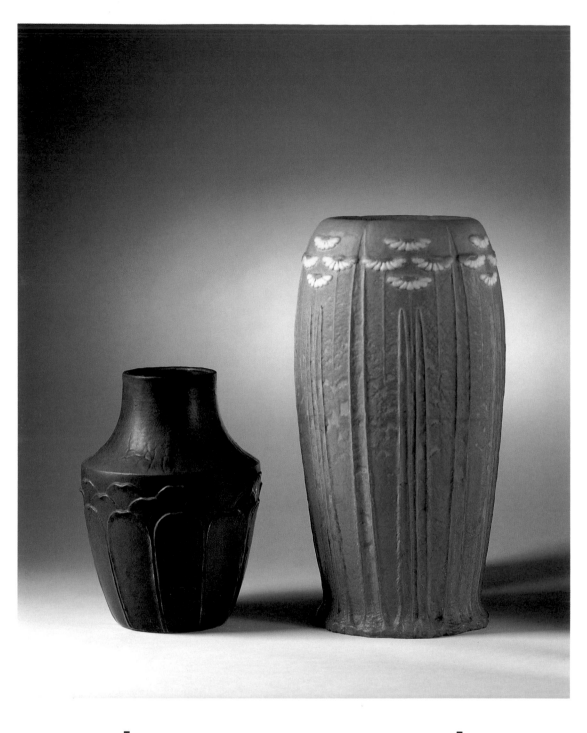

Vase, 1905

Grueby Pottery, Boston (1897–1913)
Glazed stoneware, h. 10¼ in.
Marks: Grueby Faience Co./Boston/U.S.A. (impressed);
MA (incised); Grueby Pottery (two paper labels)
PO-73-66

Vase, 1905

Ruth Erickson (active at Grueby, c. 1899–1910), decorator
Grueby Pottery, Boston (1897–1913)
Glazed stoneware, h. 16½ in.
Marks: Grueby Pottery/Boston/U.S.A. (impressed); RE conjoined
monogram/8/11/05 (incised)
PO-9-66

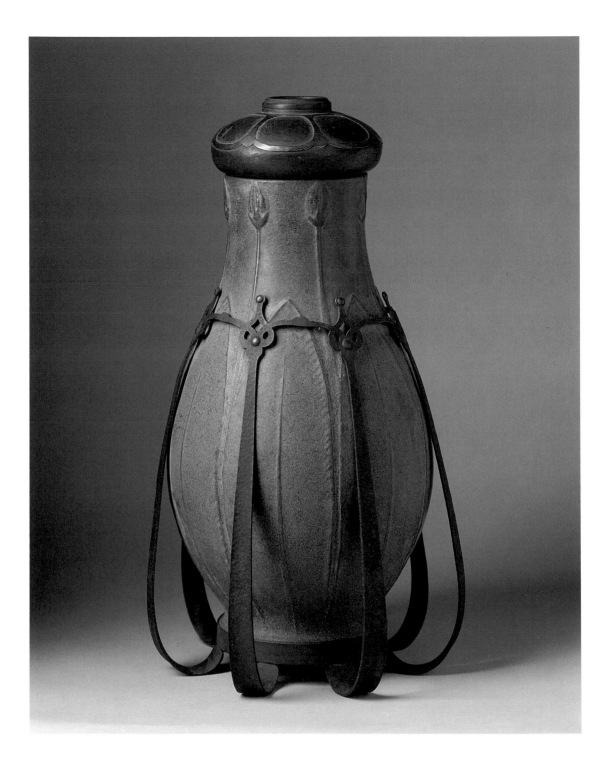

Lamp Base, c. 1897–1907

Grueby Pottery, Boston (1897–1913)
Glazed stoneware with metal framework, h. 18¼ in.
Marks: Grueby Pottery/Boston/U.S.A./220 (impressed); on lid,
sterling and other materials (engraved)
PO-52-71

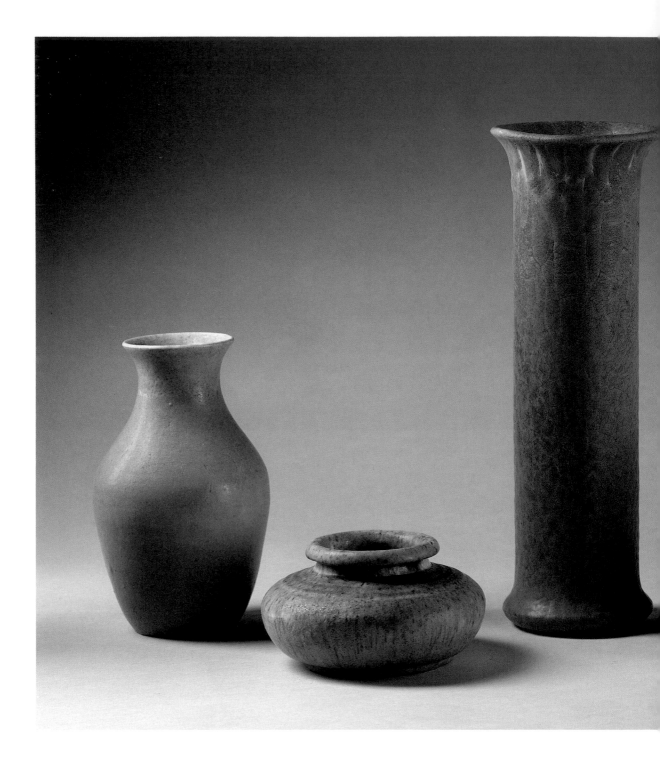

■

Vase, c. 1897–1907

Grueby Pottery, Boston (1897–1913)
Glazed stoneware, h. 7½ in.
Marks: Grueby Faience Co./Boston./U.S.A. (impressed)
PO-16-75

■

Vase, 1902

Grueby Pottery, Boston (1897–1913)
Glazed stoneware, h. 5¾ in.
Marks: Grueby Pottery Boston./U.S.A. (impressed); DS/1902/8
(incised)
PO-12-72

■

Vase, c. 1905

Grueby Pottery, Boston (1897–1913)
Glazed stoneware, h. 12⅜ in.
Marks: Grueby Pottery Boston/U.S.A. (impressed); 425 (incised)
Gift of Herbert O. and Susan C. Robinson PO-133-86

■

Vase, c. 1897–1907

Grueby Pottery, Boston (1897–1913)
Glazed stoneware, h. 3 in.
Marks: Grueby Faience Co./Boston./U.S.A. (impressed)
PO-11-72

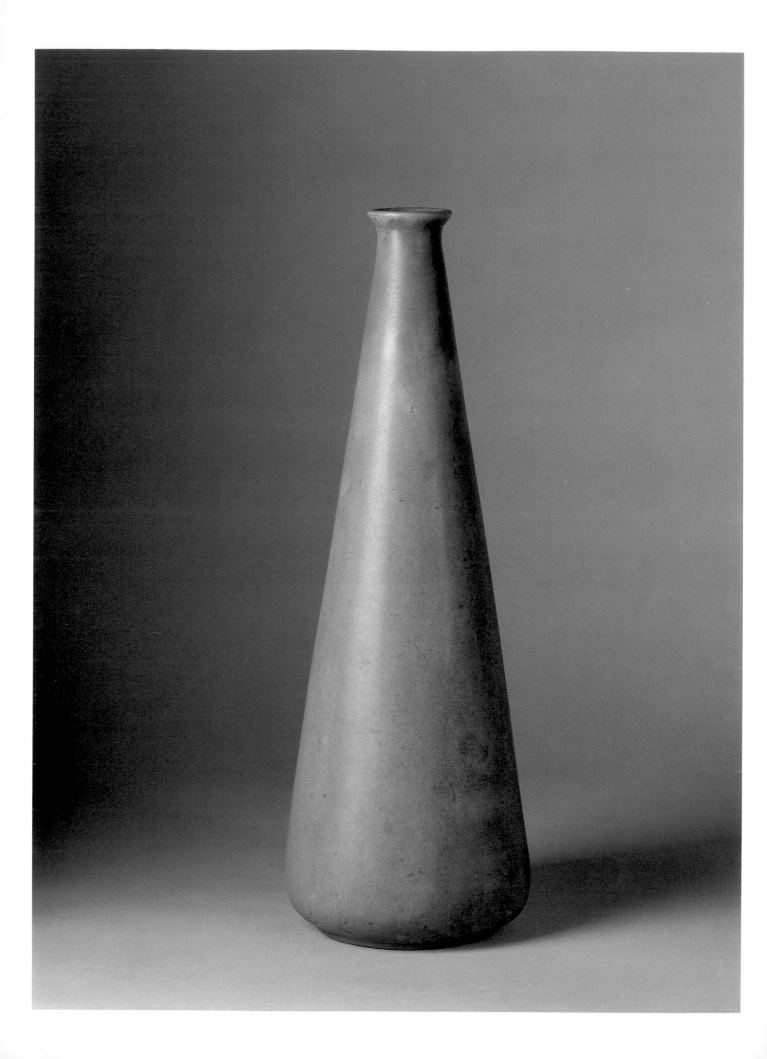

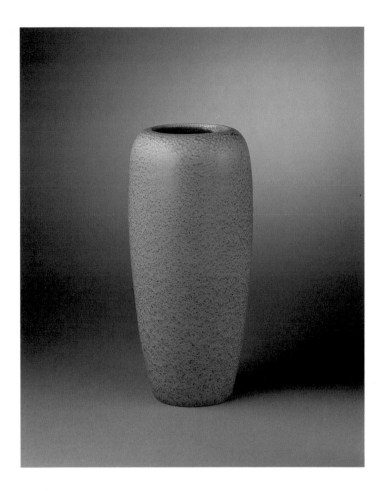

■

Vase, c. 1906–15

William D. Gates (1852–1935), designer
American Terra Cotta and Ceramic Company (Teco),
Terra Cotta, Illinois (1895–1922)
Glazed stoneware, h. 17¾ in.
Marks: Teco vertical logo (impressed twice); and original paper label
PO-30-82

■

Vase, c. 1904–14

Cadmon Robertson (d. 1914), designer
Hampshire Pottery, Keene, New Hampshire (1871–1923)
Glazed white clay, h. 10⅞ in.
Marks: Hampshire Pottery (incised)
PO-21-79

■

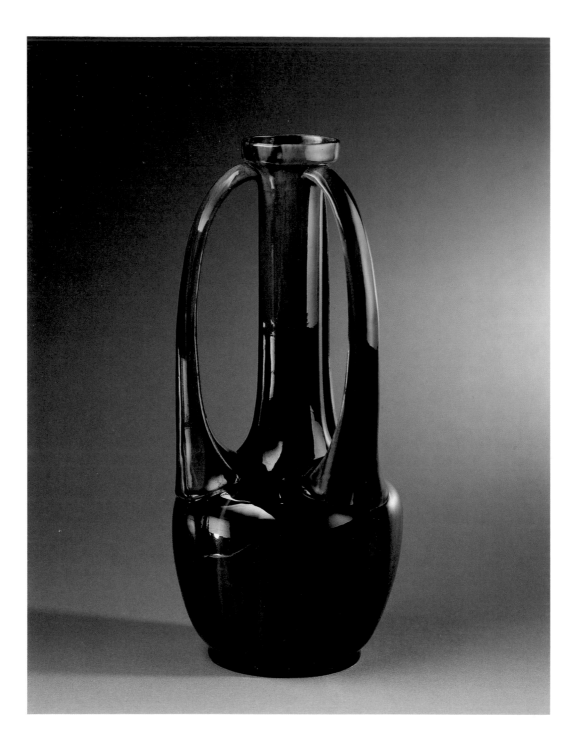

■

Vase, c. 1901–03

Wannopee Pottery, New Milford, Connecticut (1892–1903)
Glazed red clay, h. 10⅞ in.
Unmarked
PO-24-79

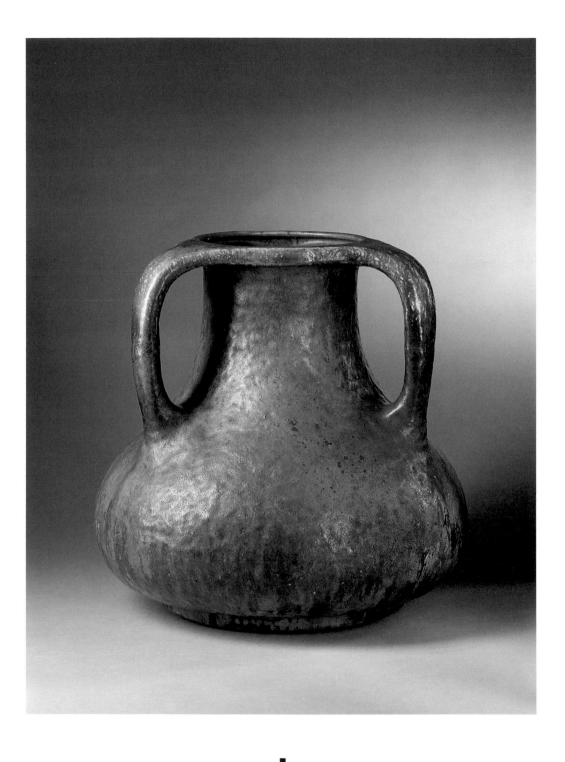

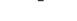

Vase, 1904–c. 1914

Louis Comfort Tiffany (1848–1933), designer
Tiffany Pottery, Corona, New York (1904–c. 1914)
Glazed white clay, h. 12¾ in.
Marks: LCT conjoined monogram/7 (incised)
78-11

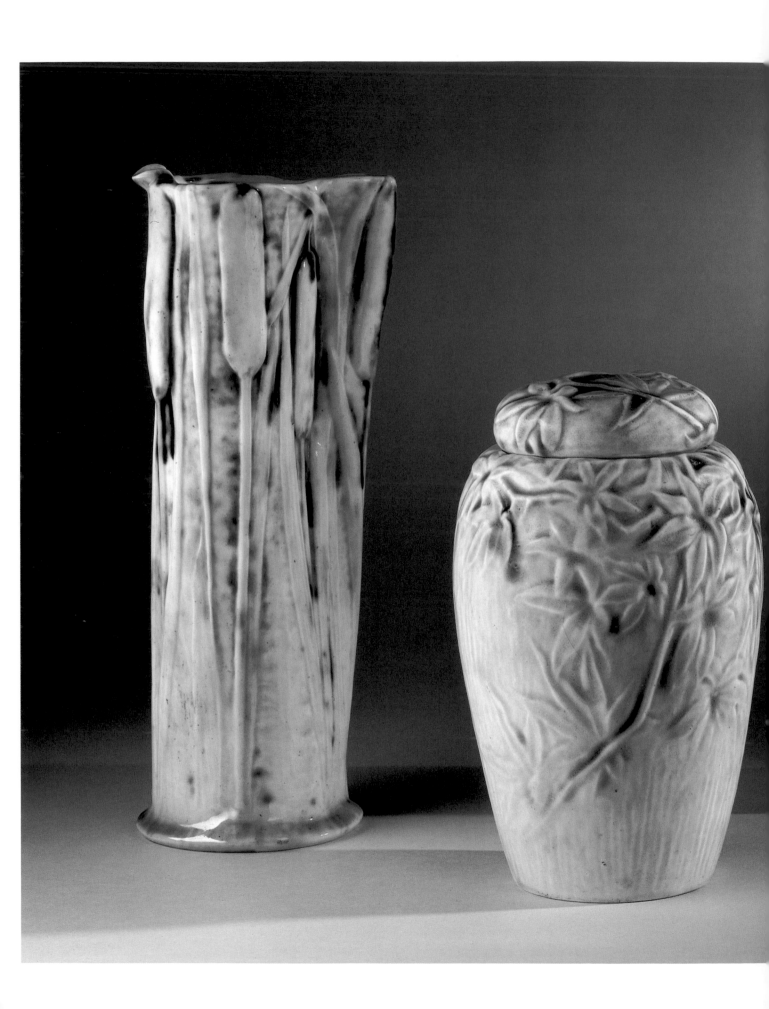

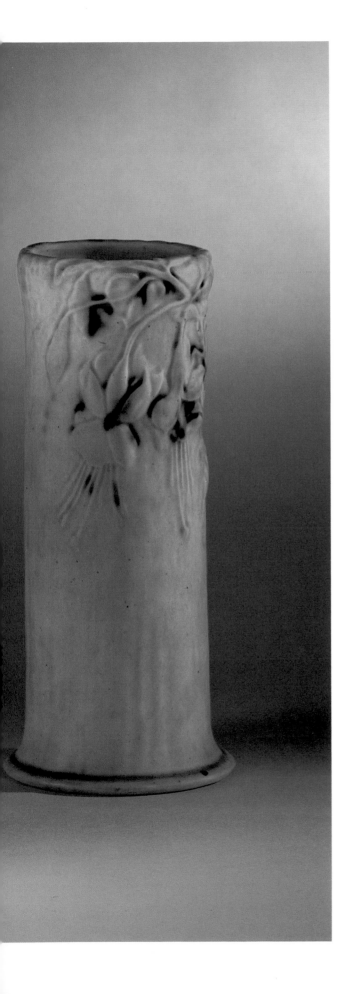

■

Pitcher, 1904–c. 1914

Louis Comfort Tiffany (1848–1933), designer
Tiffany Pottery, Corona, New York (1904–c. 1914)
Glazed white clay, h. 12⅜ in.
Marks: LCT conjoined monogram/7 (incised); L.C. Tiffany—Inc.
Favrile Pottery/P1157 (engraved)
79-527

■

Jar with Cover, 1904–c. 1914

Louis Comfort Tiffany (1848–1933), designer
Tiffany Pottery, Corona, New York (1904–c. 1914)
Glazed white clay, h. 9 in.
Marks: LCT conjoined monogram/7 (incised); L.C.T./P.15 (in pencil)
76-8A, B

■

Vase, 1904–c. 1914

Louis Comfort Tiffany (1848–1933), designer
Tiffany Pottery, Corona, New York (1904–c. 1914)
Glazed white clay, h. 10 in.
Marks: LCT conjoined monogram (stamped); L.C. Tiffany—
Favrile Pottery/P 1182 (engraved)
62-10

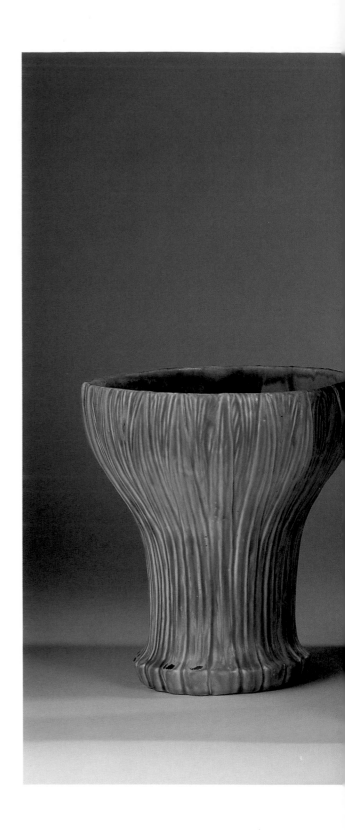

Vase, 1904–c. 1914

Louis Comfort Tiffany (1848–1933), designer
Tiffany Pottery, Corona, New York (1904–c. 1914)
Glazed white clay, h. 8 in.
Marks: LCT conjoined monogram (etched;
signature possibly added later)
76-4

Vase, 1904–c. 1914

Louis Comfort Tiffany (1848–1933), designer
Tiffany Pottery, Corona, New York (1904–c. 1914)
Glazed white clay, h. 10⅞ in.
Marks: LCT conjoined monogram/7 (incised)
80-15

Vase, 1906

Louis Comfort Tiffany (1848–1933), designer
Tiffany Pottery, Corona, New York (1904–c. 1914)
Glazed white clay, h. 12½ in.
Marks: LCT conjoined monogram/7 (incised); L.C. Tiffany—Favrile—
Pottery/Salon 1906/P525 (engraved)
89-2

Jar with Cover, 1904–c. 1914

Louis Comfort Tiffany (1848–1933), designer
Tiffany Pottery, Corona, New York (1904–c. 1914)
Glazed white clay, h. 9 in.
Marks: LCT conjoined monogram/7 (incised); L.C. Tiffany—Favrile
Pottery/P 711 (engraved)
77-2A, B

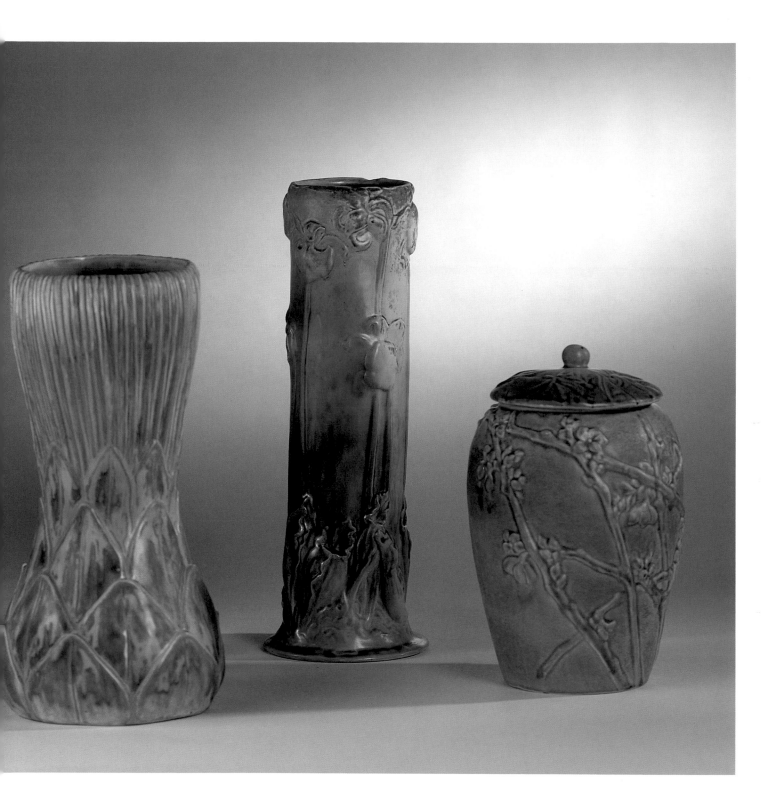

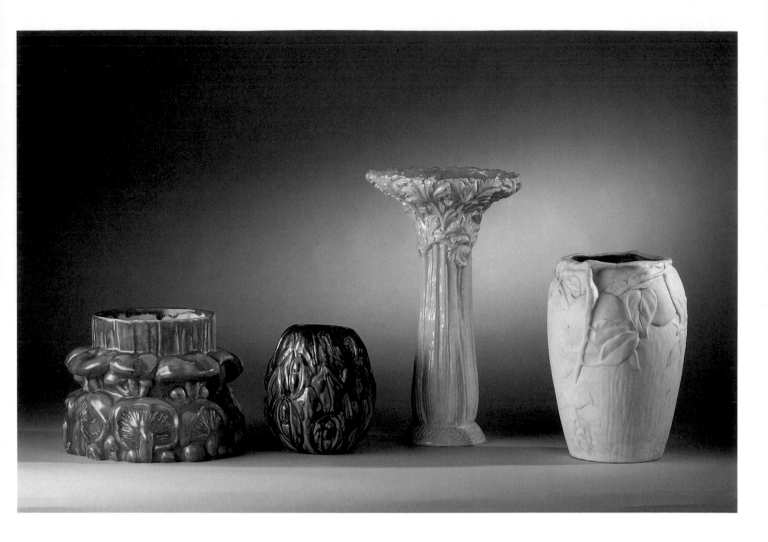

■

Vase, 1904–c. 1914

Louis Comfort Tiffany (1848–1933), designer
Tiffany Pottery, Corona, New York (1904–c. 1914)
Glazed white clay, h. 5½ in.
Marks: LCT conjoined monogram/7 (incised)
80-16

■

Vase, 1904–c. 1914

Louis Comfort Tiffany (1848–1933), designer
Tiffany Pottery, Corona, New York (1904–c. 1914)
Glazed white clay, h. 11 in.
Marks: LCT conjoined monogram (incised); P 1343/L.C. Tiffany—
Favrile Pottery (engraved)
74-26

■

Vase, 1904–c. 1914

Louis Comfort Tiffany (1848–1933), designer
Tiffany Pottery, Corona, New York (1904–c. 1914)
Glazed white clay, h. 5 in.
Marks: LCT conjoined monogram/7 (incised)
62-11

■

Vase, 1904–c. 1914

Louis Comfort Tiffany (1848–1933), designer
Tiffany Pottery, Corona, New York (1904–c. 1914)
Glazed white clay, h. 8 in.
Marks: LCT conjoined monogram/7 (incised);
P1455 L.C.T. Pottery (in pencil)
81-5

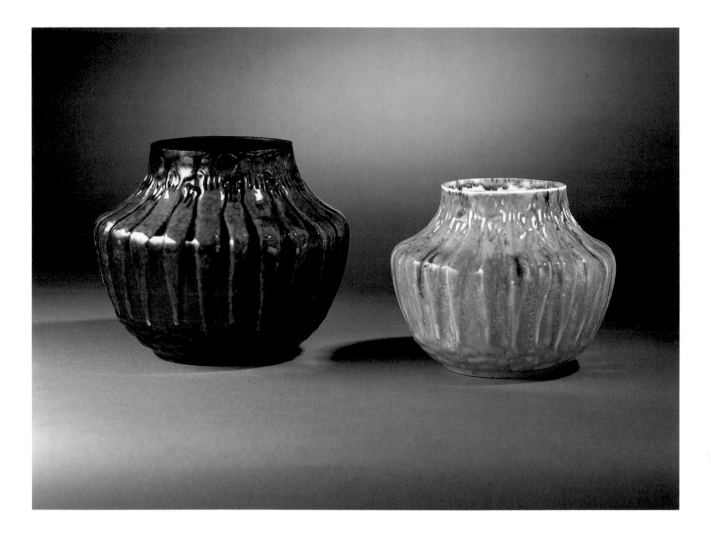

■

Vase, 1898–1902

Louis Comfort Tiffany (1848–1933), designer
Tiffany Furnaces, Corona, New York
Enamel on copper, h. 7¼ in.
Marks: 162 A—coll. L.C. Tiffany (engraved)/SG 123 (stamped)
66-1
(not in the exhibition)

■

Vase, 1904–c. 1914

Louis Comfort Tiffany (1848–1933), designer
Tiffany Pottery, Corona, New York (1904–c. 1914)
Glazed white clay, h. 6⅜ in.
Marks: LCT conjoined monogram/7 (incised)
85-8

■

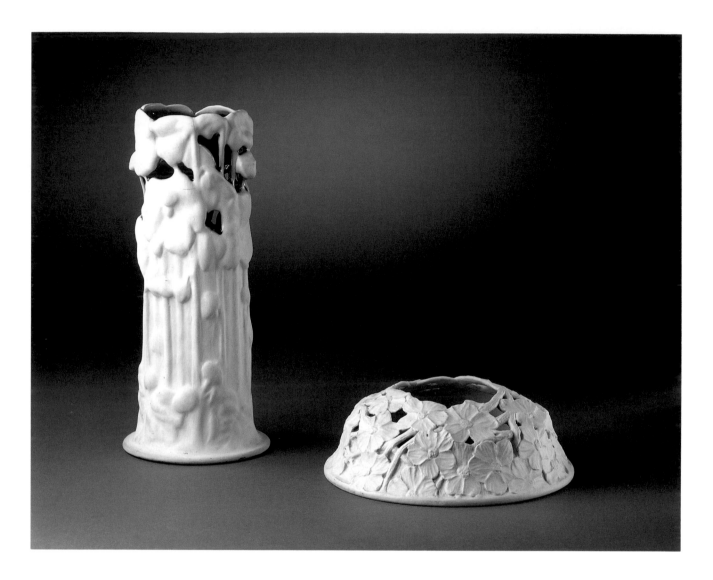

Vase, 1904–c. 1914

Louis Comfort Tiffany (1848–1933), designer
Tiffany Pottery, Corona, New York (1904–c. 1914)
Glazed white clay, h. 10¼ in.
Marks: LCT conjoined monogram/7 (incised);
L.C.T. Pottery/P1431 (in pencil)
82-8

Flower Holder, 1904–c. 1914

Louis Comfort Tiffany (1848–1933), designer
Tiffany Pottery, Corona, New York (1904–c. 1914)
White bisque, h. 2⅝ in.
Marks: LCT conjoined monogram (incised)
74-28

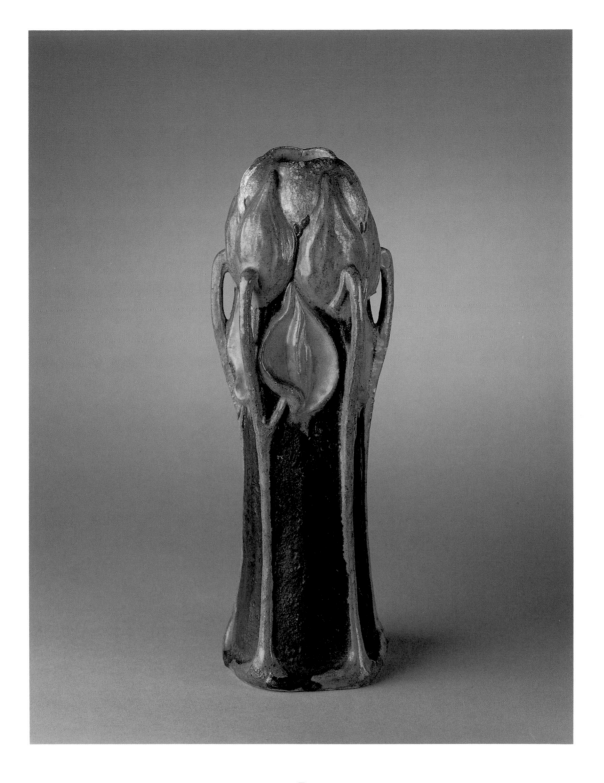

Vase, c. 1904

Alice Gouvy, designer
Tiffany Pottery, Corona, New York (1904–c. 1914)
Glazed white clay, h. 10¼ in.
Marks: LCT conjoined monogram (incised);
P/AG (incised and glazed in blue)
76-13

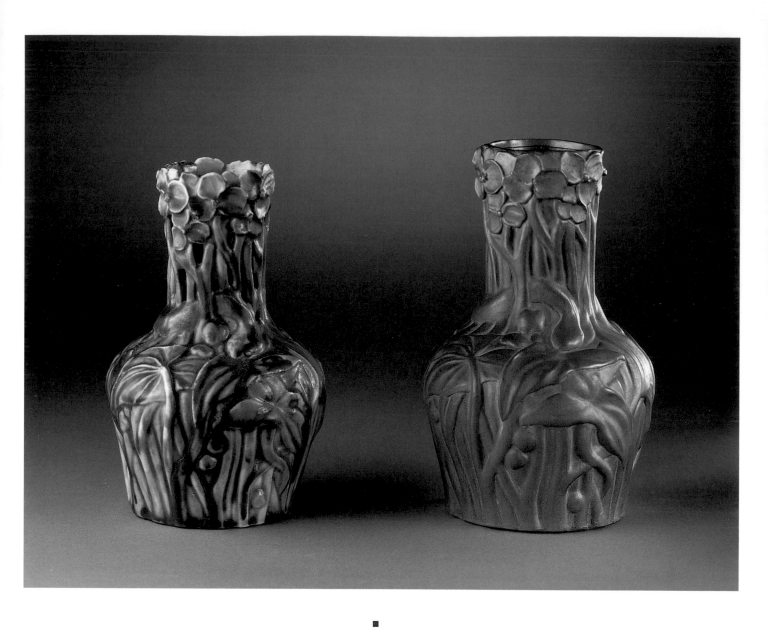

Vase, 1904–c.1914

Louis Comfort Tiffany (1848–1933), designer
Tiffany Pottery, Corona, New York (1904–c.1914)
Glazed white clay, h. 7¾ in.
Marks: partially obscured LCT conjoined monogram/7 (incised)
77-39

■

Vase, 1910–c.1914

Louis Comfort Tiffany (1848–1933), designer
Tiffany Pottery, Corona, New York (1904–c.1914)
Electroformed bronze coating and copper base
over white clay, h. 8⅜ in.
Marks: LCT conjoined monogram/8928 NW[?] (incised);
L.C. Tiffany—Favrile Bronze Pottery/B.P 315 (engraved)
79-549

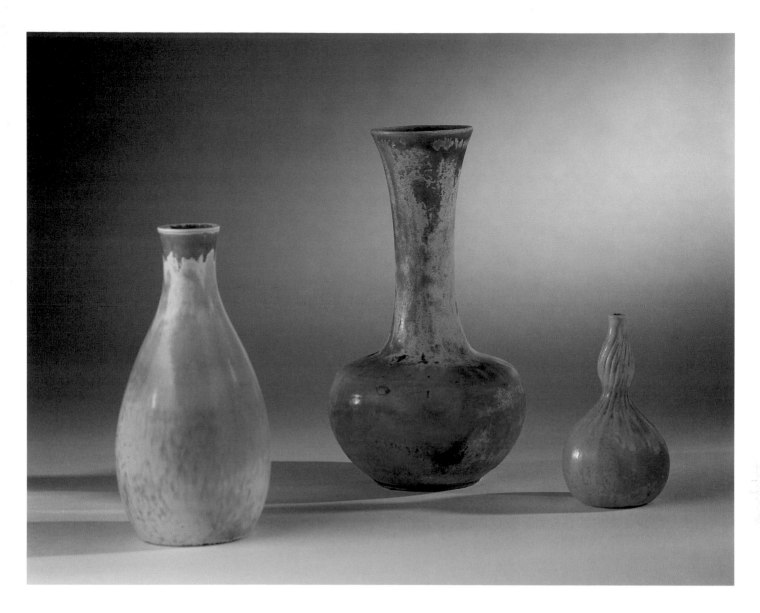

■

Vase, 1904–c. 1914

Louis Comfort Tiffany (1848–1933), designer
Tiffany Pottery, Corona, New York (1904–c. 1914)
Glazed white clay, h. 7⅝ in.
Marks: LCT conjoined monogram (incised); 129 A-Coll. L.C. Tiffany
Favrile Pottery (engraved)
55-1

■

Vase, 1904–c. 1914

Louis Comfort Tiffany (1848–1933), designer
Tiffany Pottery, Corona, New York (1904–c. 1914)
Glazed white clay, h. 5 in.
Marks: LCT conjoined monogram/7 (incised)
80-17

■

Vase, 1904–c. 1914

Louis Comfort Tiffany (1848–1933), designer
Tiffany Pottery, Corona, New York (1904–c. 1914)
Glazed white clay, h. 9¾ in.
Marks: LCT conjoined monogram (incised); L.C. Tiffany—Favrile
Pottery/P 1748 (engraved)
70-14

■

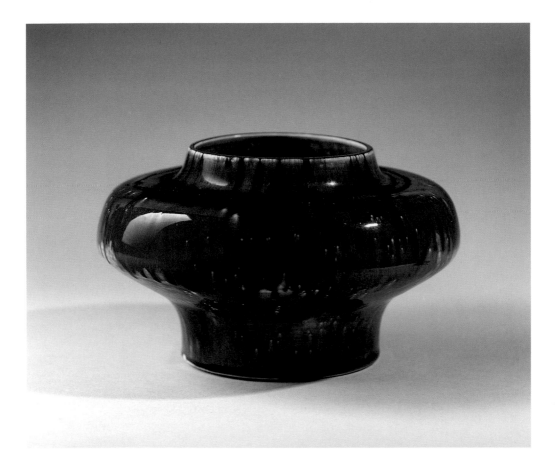

■

Vase, 1904–c. 1914

Louis Comfort Tiffany (1848–1933), designer
Tiffany Pottery, Corona, New York (1904–c. 1914)
White bisque with glazed interior, h. 10⅞ in.
Marks: LCT conjoined monogram (incised)
63-1

■

Bowl, 1904–c. 1914

Louis Comfort Tiffany (1848–1933), designer
Tiffany Pottery, Corona, New York (1904–c. 1914)
Glazed white clay, h. 5½ in.
Marks: LCT conjoined monogram/7 (incised)
66-16

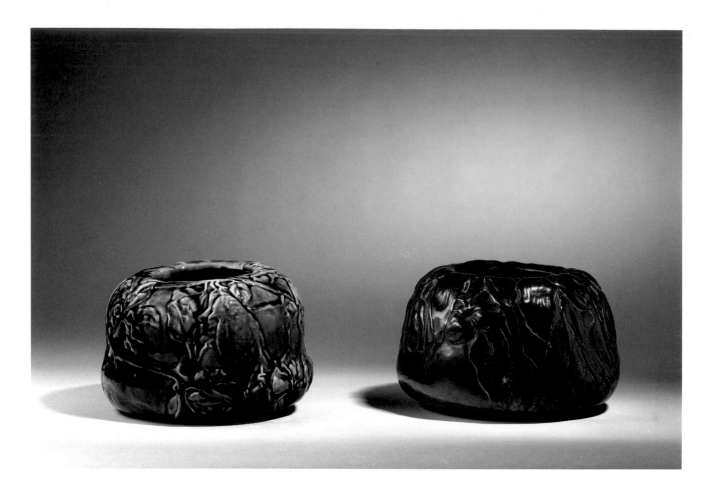

■

Bowl, 1904–c. 1914

Louis Comfort Tiffany (1848–1933), designer
Tiffany Pottery, Corona, New York (1904–c. 1914)
Glazed white clay, h. 5⅜ in.
Marks: partially obscured LCT conjoined monogram (incised)
76-9

■

Bowl, 1910–c. 1914

Louis Comfort Tiffany (1848–1933), designer
Tiffany Pottery, Corona, New York (1904–c. 1914)
Electroformed copper coating with copper base plate
and glaze over white clay, h. 5¼ in.
Marks: LCT conjoined monogram (stamped); B.P. 332/L.C. Tiffany—
Favrile Bronze Pottery (engraved)
80-13

•

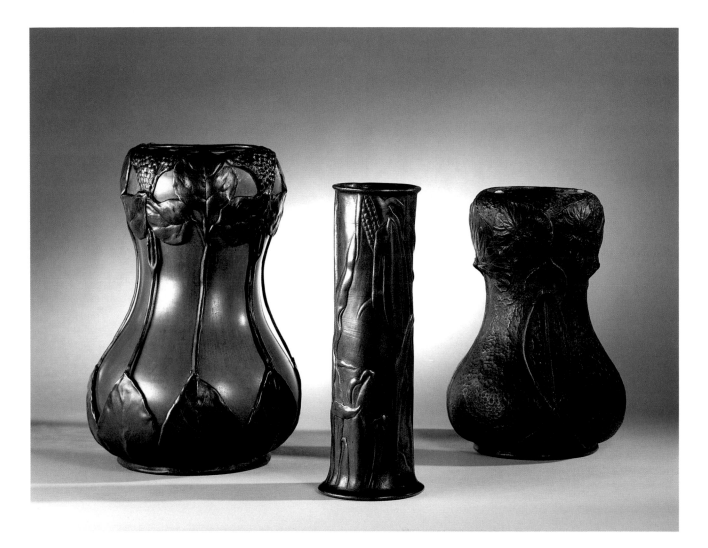

■

Vase, 1910–c. 1914

Louis Comfort Tiffany (1848–1933), designer
Tiffany Pottery, Corona, New York (1904–c. 1914)
Glazed white clay with bronze overlay, h. 14½ in.
Marks: LCT conjoined monogram/7 (incised); BP 512 L.C. Tiffany—
Favrile—Pottery/bronze (engraved); on metal base, Louis C. Tiffany
Favrile 102 (engraved)
76-30A, B

■

Vase, 1910–c. 1914

Louis Comfort Tiffany (1848–1933), designer
Tiffany Pottery, Corona, New York (1904–c. 1914)
Electroformed bronze coating over white clay, h. 12⅜ in.
Marks: LCT conjoined monogram/7 (incised); BP 515 L.C. Tiffany—
Favrile Bronze Pottery (engraved)
81-7

■

Vase, 1910–c. 1914

Louis Comfort Tiffany (1848–1933), designer
Tiffany Pottery, Corona, New York (1904–c. 1914)
Electroformed bronze coating over white clay, h. 13 in.
Marks: LCT conjoined monogram/7/6262 (incised); B.P. 279
L.C. Tiffany—Favrile Bronze Pottery (engraved)
77-26

•

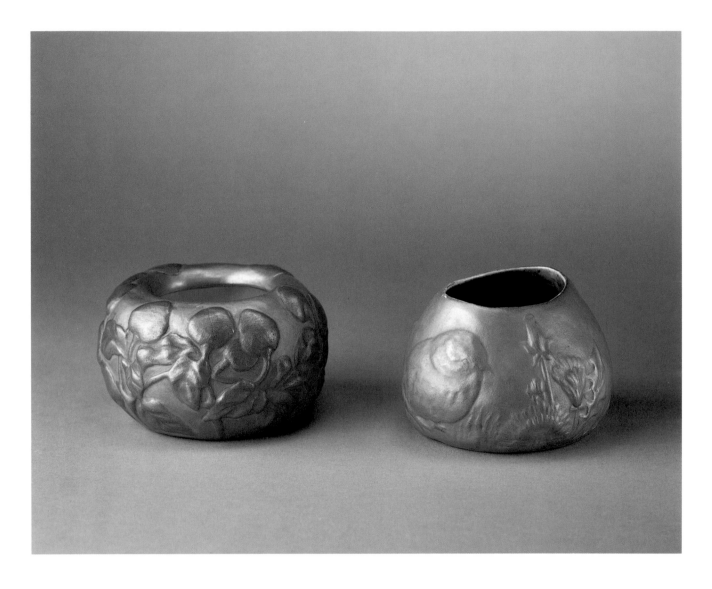

■

Bowl, 1910–c.1914

Louis Comfort Tiffany (1848–1933), designer
Tiffany Pottery, Corona, New York (1904–c.1914)
Gold coating and glaze over white clay, h. 2 in.
Marks: LCT conjoined monogram/7 (incised); L.C. Tiffany—Favrile
Bronze Pottery/BP 517[?] (engraved)
76-2

■

Bowl, 1910–c.1914

Louis Comfort Tiffany (1848–1933), designer
Tiffany Pottery, Corona, New York (1904–c.1914)
Gold coating and glaze over white clay, h. 2¼ in.
Marks: LCT conjoined monogram/7 (incised)
66-2

.

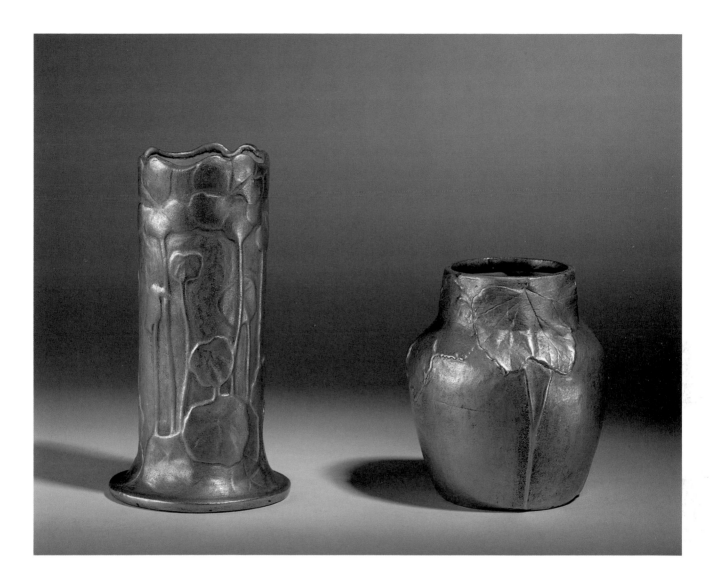

■

Vase, 1910–c. 1914

Louis Comfort Tiffany (1848–1933), designer
Tiffany Pottery, Corona, New York (1904–c. 1914)
Electroformed copper coating with copper base plate
over white clay, h. 7¼ in.
Marks: LCT conjoined monogram (stamped); 40A-Coll. L.C. Tiffany—
Favrile Bronze Pottery/B.P. 325 (engraved)
65-26

■

Vase, 1910–c. 1914

Louis Comfort Tiffany (1848–1933), designer
Tiffany Pottery, Corona, New York (1904–c. 1914)
Electroformed copper coating with copper base plate
over white clay, h. 4¾ in.
Marks: LCT conjoined monogram (stamped); L.C. Tiffany—Favrile
Bronze Pottery/B.P. 298 (engraved)
79-555

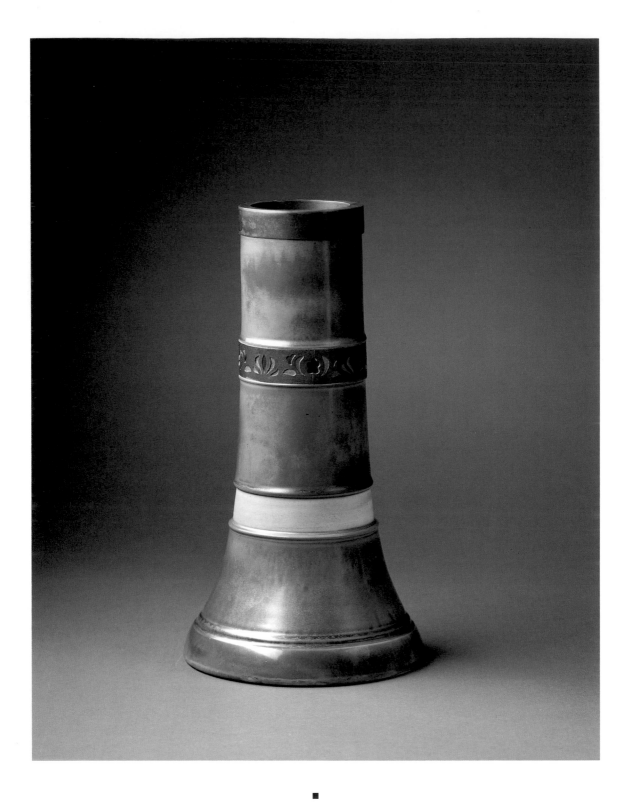

Vase, 1904–c. 1914

Louis Comfort Tiffany (1848–1933), designer
Tiffany Pottery, Corona, New York (1904–c. 1914)
Glazed white clay with copper band and
inset colored favrile glass, h. 12⅞ in.
Marks: LCT conjoined monogram/7 (incised)
66-30

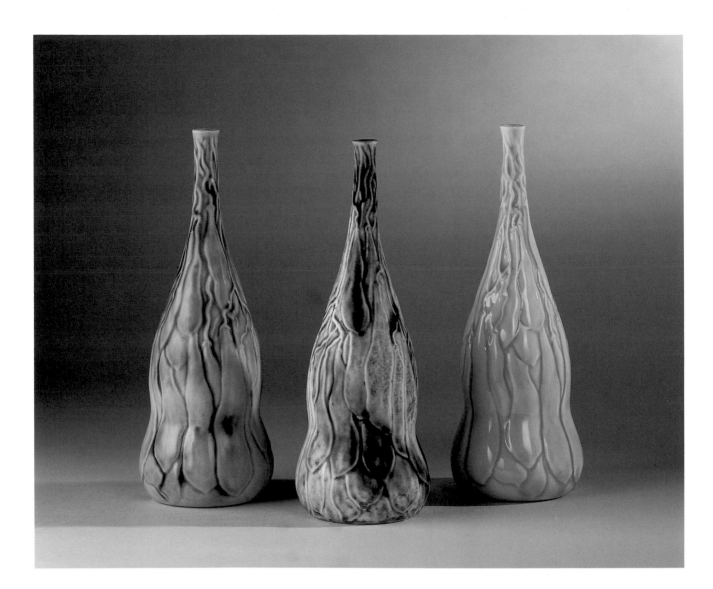

■

Vase, 1904–c. 1914

Louis Comfort Tiffany (1848–1933), designer
Tiffany Pottery, Corona, New York (1904–c. 1914)
Glazed white clay, h. 8⅞ in.
Marks: LCT conjoined monogram/7 (incised);
L.C.T Favrile—Pottery/P1249 (engraved)
84-1

■

Vase, 1904–c. 1914

Louis Comfort Tiffany (1848–1933), designer
Tiffany Pottery, Corona, New York (1904–c. 1914)
Glazed white clay, h. 9 in.
Marks: LCT conjoined monogram/7 (incised)
64-2

■

Vase, 1904–c. 1914

Louis Comfort Tiffany (1848–1933), designer
Tiffany Pottery, Corona, New York (1904–c. 1914)
Glazed white clay, h. 8⅞ in.
Marks: LCT conjoined monogram/7 (incised)
76-3

Bowl, 1910–c. 1914

Louis Comfort Tiffany (1848–1933), designer
Tiffany Pottery, Corona, New York (1904–c. 1914)
Electroformed copper coating with
copper base plate over white clay, h. 4½ in.
Marks: LCT conjoined monogram (stamped); L.C. Tiffany—Favrile
Bronze Pottery/B.P. (engraved)
55-9

Bowl, 1904–c. 1914

Louis Comfort Tiffany (1848–1933), designer
Tiffany Pottery, Corona, New York (1904–c. 1914)
White bisque, glazed interior, h. 4½ in.
Marks: LCT conjoined monogram/7 (incised)
66-18

Bowl, 1904–c. 1914

Louis Comfort Tiffany (1848–1933), designer
Tiffany Pottery, Corona, New York (1904–c. 1914)
Glazed white clay, h. 4¼ in.
Marks: LCT conjoined monogram/P (incised); conjoined 7B (glazed)
74-27

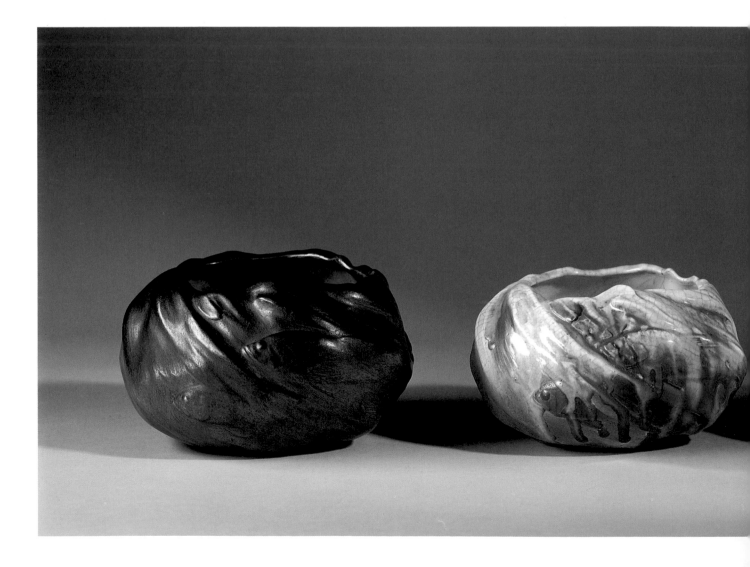

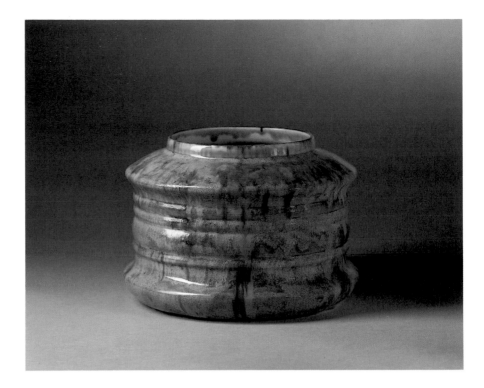

■

Vase, 1904–c. 1914

Louis Comfort Tiffany (1848–1933), designer
Tiffany Pottery, Corona, New York (1904–c. 1914)
Glazed white clay, h. 5⅞ in.
Marks: LCT conjoined monogram/7 (incised)
85-15

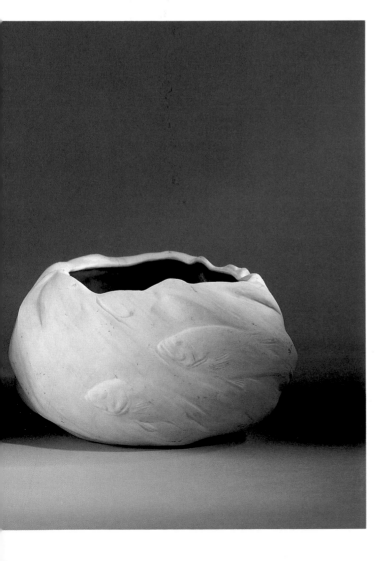

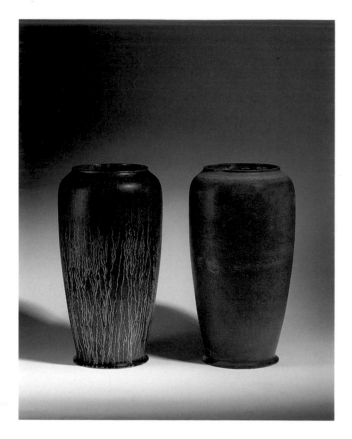

■

Vase, 1904–c. 1914

Louis Comfort Tiffany (1848–1933), designer
Tiffany Pottery, Corona, New York (1904–c. 1914)
Glazed white clay, h. 15¼ in.
Marks: LCT conjoined monogram/7 (incised); 84 A-Coll./L.C. Tiffany
Favrile Pottery (engraved)
77-42

■

Vase, 1904–c. 1914

Louis Comfort Tiffany (1848–1933), designer
Tiffany Pottery, Corona, New York (1904–c. 1914)
Glazed white clay, h. 15¼ in.
Marks: LCT conjoined monogram/7 (incised)
85-14

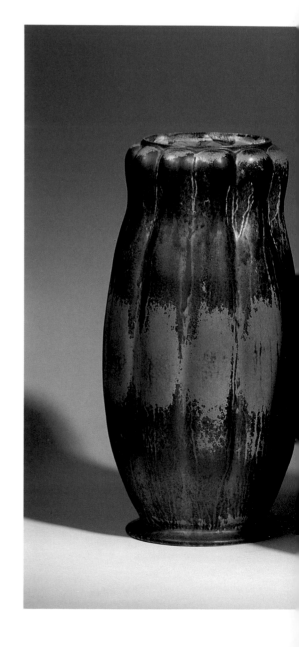

■

Vase, 1904–c. 1914

Louis Comfort Tiffany (1848–1933), designer
Tiffany Pottery, Corona, New York (1904–c. 1914)
Glazed white clay, h. 16½ in.
Marks: LCT conjoined monogram/7 (incised)
62-12

■

Vase, 1904–c. 1914

Louis Comfort Tiffany (1848–1933), designer
Tiffany Pottery, Corona, New York (1904–c. 1914)
Glazed white clay, h. 16¼ in.
Marks: LCT conjoined monogram/7 (incised); 82 A-Coll. L.C. Tiffany.
Favrile Pottery (engraved)
66-55

■

Vase, 1904–c. 1914

Louis Comfort Tiffany (1848–1933), designer
Tiffany Pottery, Corona, New York (1904–c. 1914)
Glazed white clay with bronze base, h. 16¼ in.
Marks: Tiffany Studios on bronze base (stamped)
78-233

■

Vase, 1904–c. 1914

Louis Comfort Tiffany (1848–1933), designer
Tiffany Pottery, Corona, New York (1904–c. 1914)
Glazed white clay, h. 16⅛ in.
Marks: LCT conjoined monogram/7 (incised) partially obscured by
original rectangular paper label with Tiffany Pottery #P1554
78-14

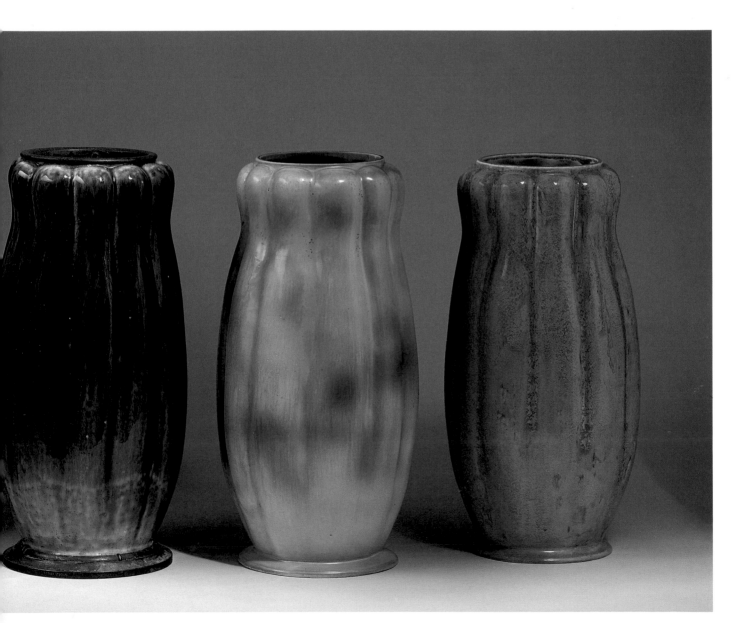

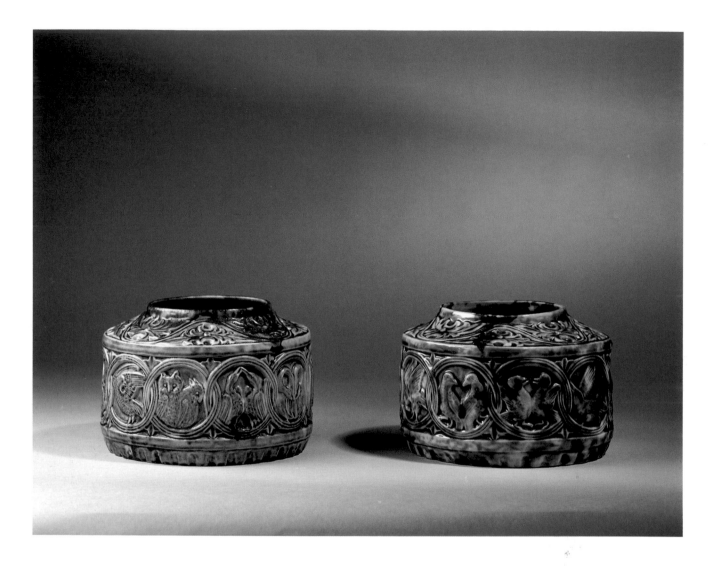

■

Bowl, 1904–c. 1914

Louis Comfort Tiffany (1848–1933), designer
Tiffany Pottery, Corona, New York (1904–c. 1914)
Glazed white clay, h. 5½ in.
Marks: LCT conjoined monogram (incised)
76-16

■

Bowl, 1904–c. 1914

Louis Comfort Tiffany (1848–1933), designer
Tiffany Pottery, Corona, New York (1904–c. 1914)
Glazed white clay, h. 5¼ in.
Marks: LCT conjoined monogram/7 (incised)
87-27

.

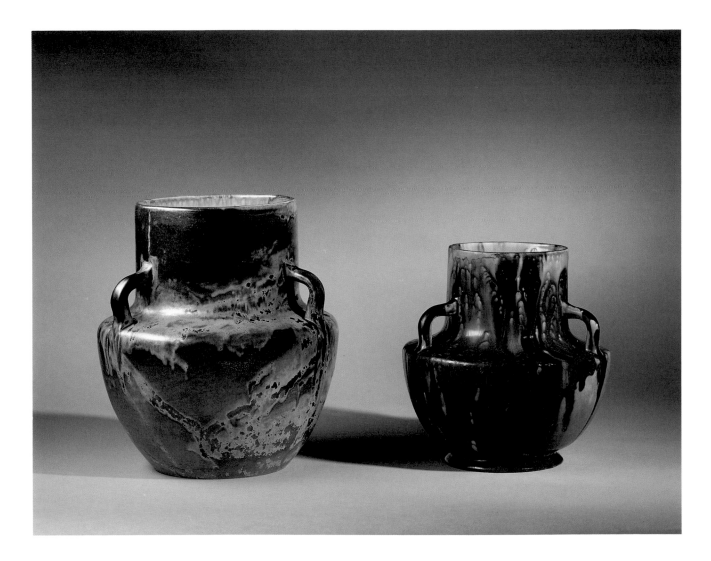

■

Vase, 1904–c. 1914

Louis Comfort Tiffany (1848–1933), designer
Tiffany Pottery, Corona, New York (1904–c. 1914)
Glazed white clay, h. 10⅞ in.
Marks: LCT conjoined monogram/7 (incised); L.C. Tiffany—
Favrile Pottery/201 A-Coll. (engraved)
79-532

■

Vase, 1904–c. 1914

Louis Comfort Tiffany (1848–1933), designer
Tiffany Pottery, Corona, New York (1904–c. 1914)
Glazed white clay, h. 6 in.
Marks: LCT conjoined monogram/7 (incised)
76-15

■

Vase, 1904–c. 1914

Louis Comfort Tiffany (1848–1933), designer
Tiffany Pottery, Corona, New York (1904–c. 1914)
Glazed white clay, h. 6½ in.
Marks: LCT conjoined monogram/7 (incised)
66-17

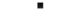

Vase, 1904–c. 1914

Louis Comfort Tiffany (1848–1933), designer
Tiffany Pottery, Corona, New York (1904–c. 1914)
Glazed white clay, h. 6½ in.
Marks: LCT conjoined monogram/7 (incised)
76-14

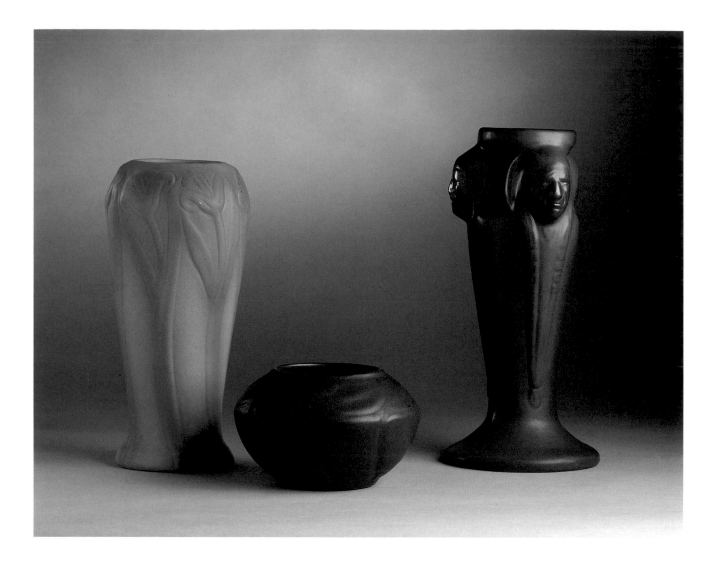

■

Vase, after 1920

Van Briggle Pottery, Colorado Springs (1902–present)
Glazed stoneware, h. 9⅞ in.
Marks: AA conjoined monogram/Van Briggle/Colo. Spgs. (incised)
PO-70-66

■

Vase, after 1920

Van Briggle Pottery, Colorado Springs (1902–present)
Glazed stoneware, h. 11 in.
Marks: AA conjoined monogram/Van Briggle/Colo Spgs. (incised)
PO-69-66

■

Bowl, after 1920

Van Briggle Pottery, Colorado Springs (1902–present)
Glazed stoneware, h. 3¾ in.
Marks: AA conjoined monogram/Van Briggle/USA (incised)
PO-67-66

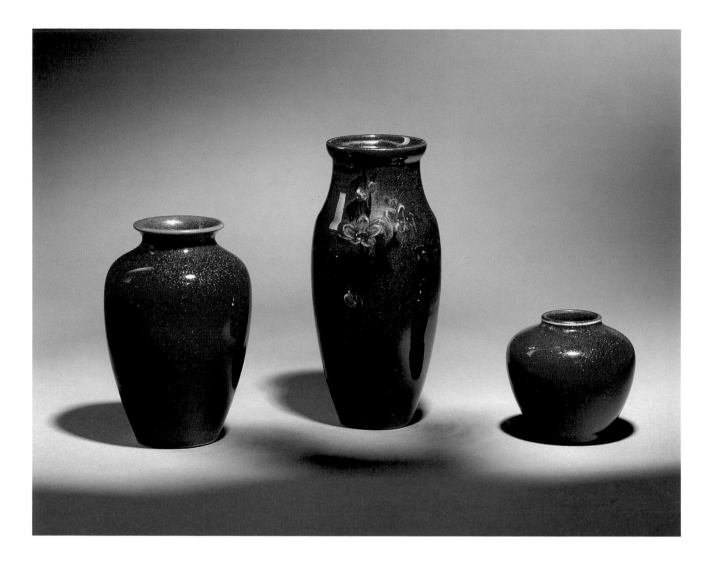

■

Vase, 1939

Rookwood Pottery, Cincinnati (1880–1967)
Glazed white clay, h. 5⅜ in.
Marks: Rookwood logo surmounted by fourteen flames/XXXIX/S
Gift of Herbert O. and Susan C. Robinson PO-25-88

■

Vase

Rookwood Pottery, Cincinnati (1880–1967)
Glazed white clay, h. 3 in.
Marks: partially obscured Rookwood logo (impressed);
original Rookwood Pottery label
PO-40-76

■

Vase, 1893

Amelia Browne Sprague (1870–1951), decorator
Rookwood Pottery, Cincinnati (1880–1967)
Glazed red clay, h. 7⅜ in.
Marks: Rookwood logo surmounted by seven flames/583 E/R
(impressed); ABS. conjoined monogram/T.I. (incised)
PO-9-82

■

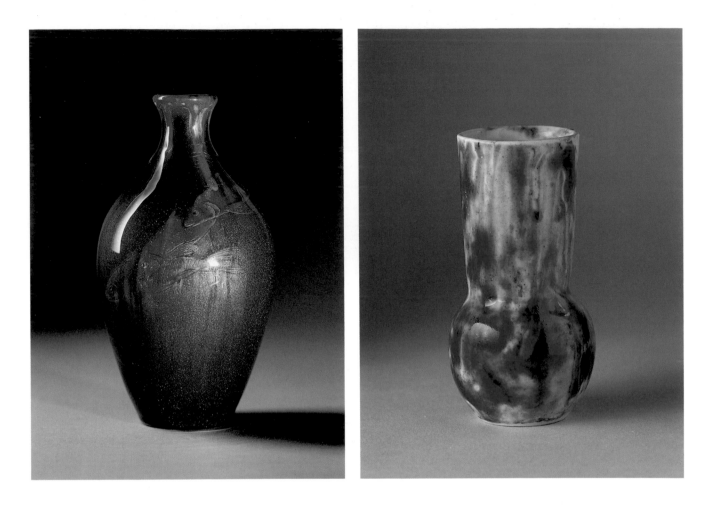

■

Vase, 1898

Artus Van Briggle (1869–1904), decorator
Rookwood Pottery, Cincinnati (1880–1967)
Glazed red clay, h. 7¾ in.
Marks: Rookwood logo surmounted by twelve flames/745 B
(impressed); AVB conjoined monogram (incised)
PO-15-94

■

Vase, c. 1900–06

M. Louise McLaughlin (1847–1939)
Losanti, Cincinnati (c. 1900–06)
Glazed porcelain, h. 4⅜ in.
Marks: MLMC conjoined monogram/CO/70 (incised)
PO-21-84

■

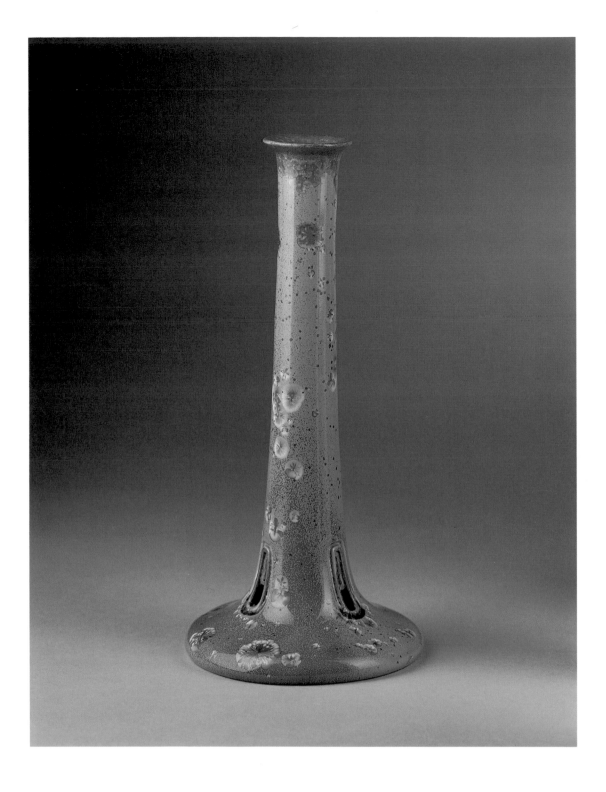

Vase, 1921

Adelaide Alsop Robineau (1865–1929)
Robineau Pottery, Syracuse, New York (c. 1904–29)
Glazed porcelain, h. 9¼ in.
Marks: AR conjoined monogram (excised); 17/1921 (incised)
PO-52-85

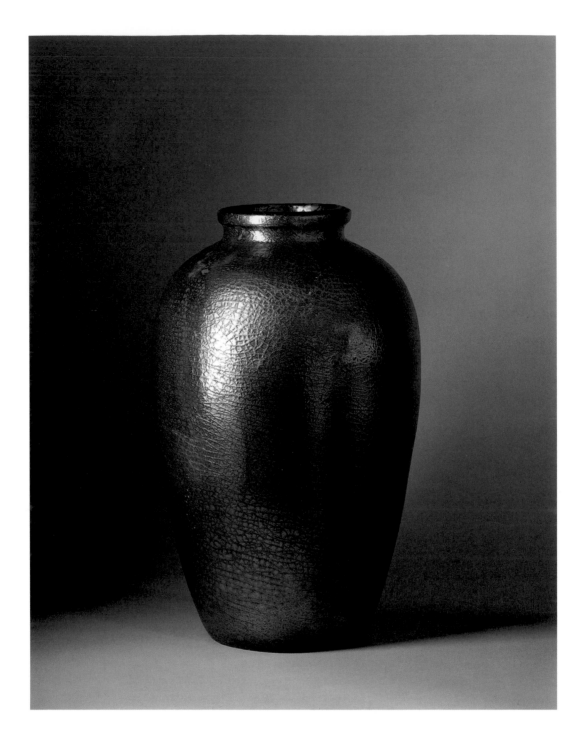

Vase, c. 1903–10

Pewabic Pottery, Detroit (1903–61)
Glazed white clay, h. 19 in.
Marks: Pewabic Detroit (impressed)
PO-22-71

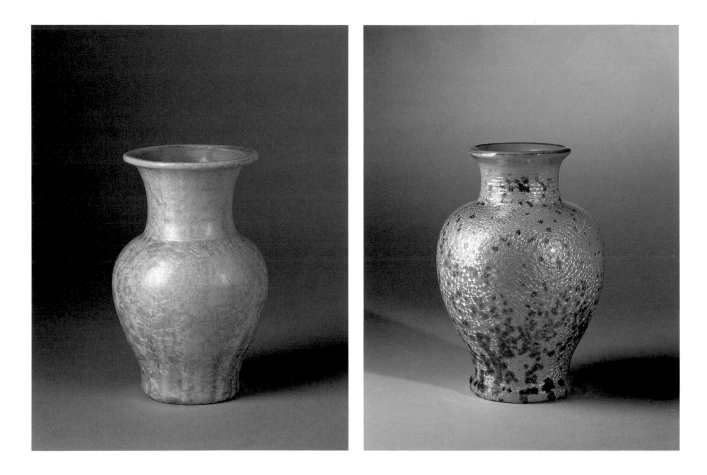

■

Vase, 1936

Walter Benjamin Stephen (1875–1961)
Pisgah Forest, Mount Pisgah, North Carolina
Glazed white clay, h. 7⅛ in.
Marks: Pisgah Forest/logo (potter at kickwheel)/1936/W B Stephen
(in relief)
PO-11-84

■

Vase, c. 1910–29

Fulper Pottery, Flemington, New Jersey (1860–c. 1935)
Glazed stoneware, h. 9½ in.
Marks: Fulper (stamped vertical logo)
PO-65-87

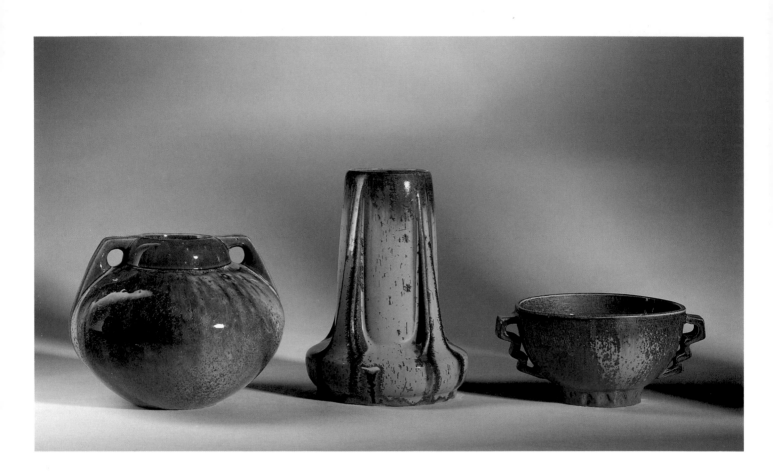

■

Vase, c. 1910–29

Fulper Pottery, Flemington, New Jersey (1860–c. 1935)
Glazed stoneware, h. 6 in.
Marks: Fulper (stamped vertical logo)
PO-38-69

■

Bowl with Handles, c. 1910–29

Fulper Pottery, Flemington, New Jersey (1860–c. 1935)
Glazed stoneware, h. 3½ in.
Marks: Fulper (impressed)
Gift of Herbert O. and Susan C. Robinson PO-45-90

■

Vase, c. 1910–29

Fulper Pottery, Flemington, New Jersey (1860–c. 1935)
Glazed stoneware, h. 8½ in.
Marks: Fulper (stamped vertical logo)
PO-13-82

■

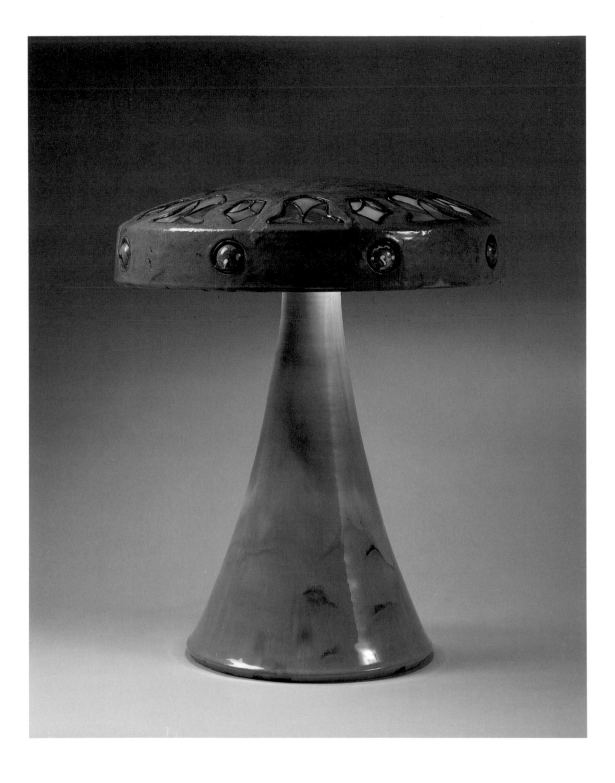

Lamp, c. 1910–29

Fulper Pottery, Flemington, New Jersey (1860–c. 1935)
Glazed stoneware with inset leaded glass, h. 20½ in.
Marks: 1/1/1/ (impressed on shade); WE (glazed in green);
on base, Fulper (stamped vertical logo); patent pending U.S.
and ...[']/Vasecraft logo and Fulper/805 (glazed)
PO-24-84

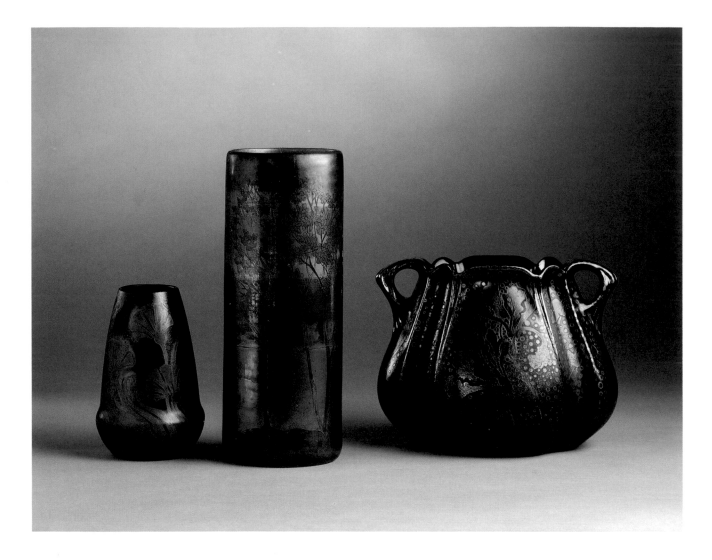

■

Vase, c. 1902–07

Jacques Sicard (1865–1923), decorator
S.A. Weller Pottery, Zanesville, Ohio (1872–1949)
Metallic glazed white clay, h. 5 in.
Marks: 73 (incised); on side, Sicard Weller (glazed)
PO-5-66

■

Vase, c. 1902–07

Jacques Sicard (1865–1923), decorator
S.A. Weller Pottery, Zanesville, Ohio (1872–1949)
Metallic glazed white clay, h. 5½ in.
Marks: 29 (inscribed); on side, Weller/Sicard (glazed)
PO-47-69

■

Vase, after 1920

John Lessell, designer
S.A. Weller Pottery, Zanesville, Ohio (1872–1949)
Metallic glazed white clay, h. 9 in.
Marks: on side, Weller—LaSa (glazed)
PO-9-77

146
.

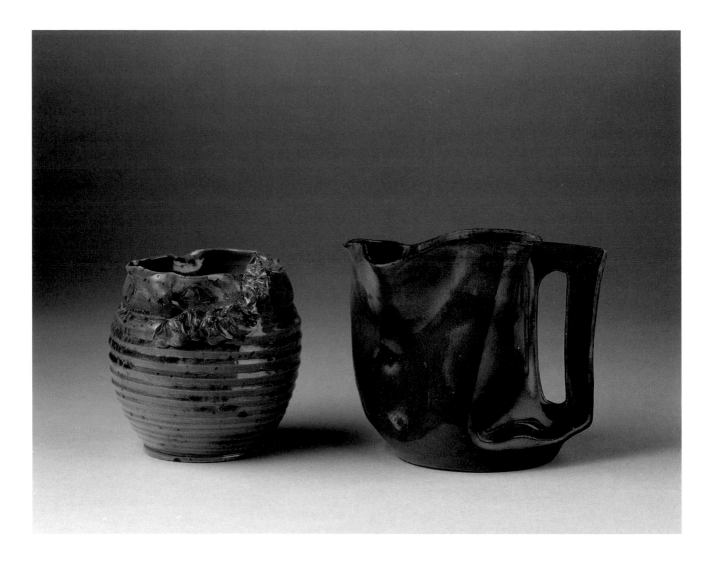

■

Vase, c. 1894–1906

George E. Ohr (1857–1918)
Biloxi Art Pottery, Biloxi, Mississippi (c. 1882–1910)
Glazed red clay, h. 3⅜ in.
Marks: G.E. Ohr/Biloxi, Miss. (impressed)
PO-17-92

■

Pitcher, c. 1894–1906

George E. Ohr (1857–1918)
Biloxi Art Pottery, Biloxi, Mississippi (c. 1882–1910)
Glazed red clay, h. 4 in.
Marks: GE Ohr (incised in script)
PO-18-75

SELECTED BIBLIOGRAPHY

■

Arnest, Barbara M. *Van Briggle Pottery: The Early Years* (exhibition catalogue). Colorado Springs: Colorado Springs Fine Arts Center, 1975.

Barber, Edwin Atlee. *Pottery and Porcelain of the United States.* 3rd edition, 1909. Reprint, New York: Feingold and Lewis, 1976.

Blasberg, Robert W., with Carol L. Bohdan. *Fulper Art Pottery: An Aesthetic Appreciation, 1909–1929* (exhibition catalogue). New York: The Jordan-Volpe Gallery, 1979.

Bowman, Leslie Greene. *American Arts & Crafts: Virtue in Design* (exhibition catalogue). Los Angeles: Los Angeles County Museum of Art, 1990.

Clark, Garth. *A Century of Ceramics in the United States, 1878–1978* (exhibition catalogue). Syracuse, New York: Everson Museum of Art.

Clark, Robert Judson, ed. *The Arts and Crafts Movement in America, 1876–1916.* Princeton, New Jersey: Princeton University Press, 1972.

Cooper-Hewitt Museum. *American Art Pottery.* New York: Cooper-Hewitt Museum, The Smithsonian Institution's National Museum of Design, 1987.

Darling, Sharon S. *Teco: Art Pottery of the Prairie School* (exhibition catalogue). Erie, Pennsylvania: Erie Art Museum, 1989.

Dietz, Ulysses G. *The Newark Museum Collection of American Art Pottery.* Newark, New Jersey: The Newark Museum, 1984.

Eidelberg, Martin, ed. *From Our Native Clay: Art Pottery from the Collections of the American Ceramic Arts Society* (exhibition catalogue). New York: The American Ceramic Arts Society, 1987.

————. "Myths of Style and Nationalism: American Art Pottery at the Turn of the Century." *The Journal of Decorative and Propaganda Arts, 1875–1945,* 20 (1994), pp. 84–111.

————. "Tiffany Favrile Pottery: A New Study of a Few Known Facts." *Connoisseur,* 169 (September 1968), pp. 57–61.

Ellis, Anita J. *Rookwood Pottery: The Glorious Gamble* (exhibition catalogue). Cincinnati: Cincinnati Art Museum, 1992.

Evans, Paul. *Art Pottery of the United States.* 2d rev. ed. New York: Feingold & Lewis Publishing Corp., 1987.

Frelinghuysen, Alice Cooney. "Aesthetic Forms in Ceramics and Glass." In *In Pursuit of Beauty: Americans and the Aesthetic Movement* (exhibition catalogue). New York: The Metropolitan Museum of Art, 1986, pp. 198–251.

————. *American Porcelain, 1770–1920.* New York: The Metropolitan Museum of Art, 1989.

Kaplan, Wendy. *"The Art That Is Life": The Arts & Crafts Movement in America, 1875–1920* (exhibition catalogue). Boston: Museum of Fine Arts, 1987.

Keen, Kirsten Hoving. *American Art Pottery, 1875–1930* (exhibition catalogue). Wilmington, Delaware: Delaware Art Museum, 1978.

Levin, Elaine. "Ceramics: Seeking a Personal Style." In *The Ideal Home, 1900–1920* (exhibition catalogue). New York: American Craft Museum, 1994, pp. 77–91.

McKean, Hugh F. *The "Lost" Treasures of Louis Comfort Tiffany.* Garden City, New York: Doubleday & Co., 1980.

Montgomery, Susan J. *The Ceramics of William H. Grueby: The Spirit of the New Idea in Artistic Handicraft.* Lambertville, New Jersey: Arts & Crafts Quarterly Press, 1993.

Pear, Lillian Myers. *The Pewabic Pottery: A History of Its Products and Its People.* Des Moines, Iowa: Wallace-Homestead Book Co., 1976.

Peck, Herbert. *The Book of Rookwood Pottery.* New York: Crown Publishers, 1968.

————. *The Second Book of Rookwood Pottery.* Tuscon, Arizona: Herbert Peck, 1985.

Perry, Barbara Stone. *Fragile Blossoms, Enduring Earth: The Japanese Influence on American Ceramics* (exhibition catalogue). Syracuse, New York: Everson Museum of Art, 1989.

Poesch, Jessie. *Newcomb Pottery: An Enterprise for Southern Women, 1895–1940.* Exton, Pennsylvania: Schiffer Publishing, 1984.

Trapp, Kenneth R. "Maria Longworth Storer: A Study of Her Bronze Objets d'Art in the Cincinnati Art Museum." Master's thesis. New Orleans: Tulane University, 1972.

————. *Ode to Nature: Flowers and Landscapes of the Rookwood Pottery, 1880–1940* (exhibition catalogue). New York: The Jordan-Volpe Gallery, 1980.

————. *Toward the Modern Style: Rookwood Pottery, The Later Years: 1915–1950* (exhibition catalogue). New York: The Jordan-Volpe Gallery, 1983.

Weiss, Peg, ed. *Adelaide Alsop Robineau: Glory in Porcelain* (exhibition catalogue). Syracuse, New York: Everson Museum of Art, 1981.

Young, Jennie J. *The Ceramic Art: A Compendium of the History and Manufacture of Pottery and Porcelain.* New York: Harper & Brothers, 1878.

INDEX OF POTERIES

■

ORLANDO MUSEUM OF ART
STAFF

■

Marena Grant Morrisey Executive Director

Bobbie Winslow Administrative Assistant to Executive Director

Sue Scott Curator of Contemporary American Art

Valerie Leeds Curator of 19th and Early 20th Century American Art

Hansen Mulford Curator of Exhibitions

Andrea Farnick Registrar

Betsy Gwinn Assistant Registrar

Kevin Boylan Preparator

Susan Rosoff Curator of Education

Wanda Edwards School Program Coordinator

Alice Vegas Public Program Coordinator

Jan Clanton Adult Program Specialist

Angilyn Watson Education Program Assistant

Donna Burton Development Secretary

Darlene Johnson-Sanchez Membership and Rental Sales Coordinator

Jean Grono Controller

Shirley Kay Torres Accounting Clerk

Jeffrey Sellers Building Superintendent

Alexis Garcia Assistant to Building Superintendent

Jesus Santiago Facilities Assistant

Chester Bennett Facilities Assistant

Sarah O'Connor Museum Shop Manager

Ava Maxwell Assistant Museum Shop Manager

Linda Hunicke Museum Shop Clerk

Nicole Candela Visitor Information Specialist

Cathy Gilmer Visitor Information Specialist